Edouard Baldus
at the Château
de La Faloise

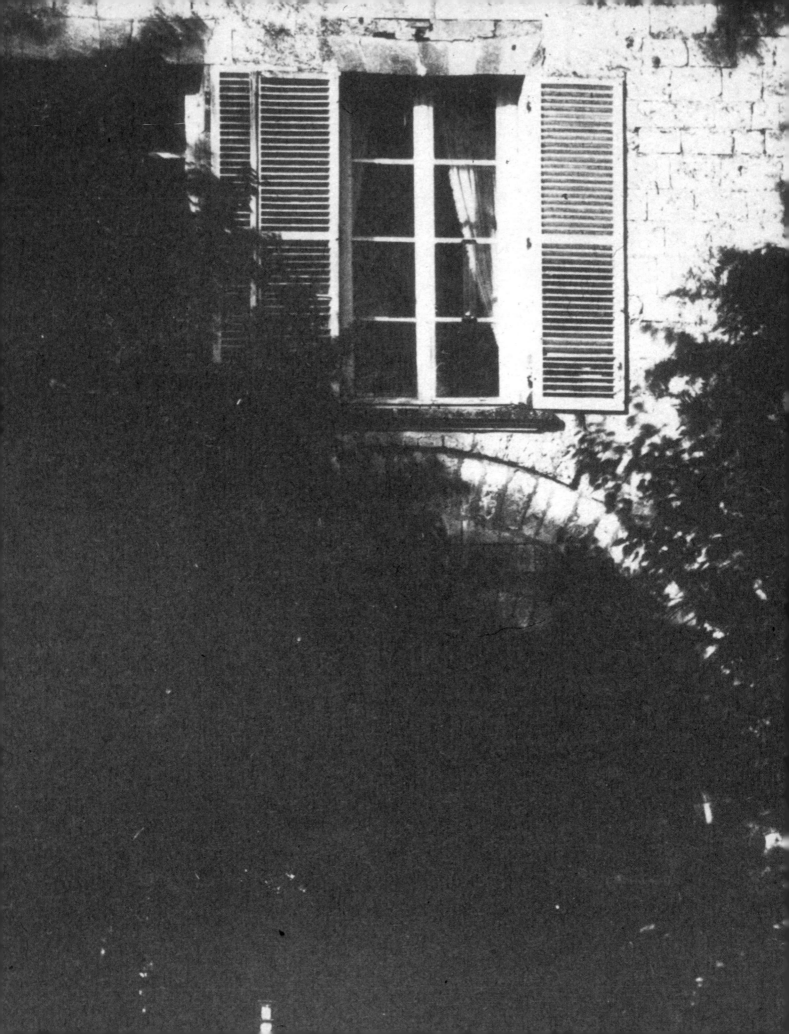

Edouard Baldus
at the Château
de La Faloise

James A. Ganz

Sterling and Francine Clark Art Institute
Williamstown, Massachusetts

Distributed by Yale University Press, New Haven and London

Produced by the Publications Department of the
Sterling and Francine Clark Art Institute
225 South Street, Williamstown, Massachusetts 01267

Curtis R. Scott, *Director of Publications*
David Edge, *Graphic Design and Production Manager*
Katherine Pasco Frisina, *Production Editor*
Mari Yoko Hara, *Publications and Curatorial Intern*

Color separations and printing by
QuinnMagna, Enfield, Connecticut
Composed in Myriad Pro and Trebuchet MS

Distributed by Yale University Press, New Haven and London
www.yalebooks.com

Printed and bound in the United States of America
10 9 8 7 6 5 4 3 2 1

Library of Congress Cataloging-in-Publication Data

Ganz, James A.
 Edouard Baldus at the Château de la Faloise / James A. Ganz
 p. cm.
 ISBN 978-0-931102-57-8 (Clark pbk. : alk. paper)
 ISBN 978-0-300-10352-6 (Yale)
 1. Photography, Artistic—Exhibitions. 2. Baldus,
Edouard, 1813–1889—Exhibitions. 3. Photography—
France—History—19th century—Exhibitions.
4. Château de la Faloise (La Faloise, France)—Pictorial
works—Exhibitions. I. Baldus, Edouard, 1813–1889. II. Title.

TR647.B334G36 2005
770'.92—dc22
[B]
 2005051720

Frontispiece: Detail of *Château de La Faloise, Late Afternoon,* 1856 (Private collection, New York)

Page 8: Detail of *Footbridge at La Faloise I,* 1856 (Musée d'Orsay, Paris. Gift of the Kodak-Pathé Foundation)

Page 14: Detail of *Tower of the Château de La Faloise,* 1856 (Sterling and Francine Clark Art Institute, Williamstown, Massachusetts)

Page 18: Detail of *Château de La Faloise, Late Morning,* 1856 (Sterling and Francine Clark Art Institute, Williamstown, Massachusetts)

Page 24: Detail of *Self-Portrait in the Tuileries,* c. 1856 (Collection of the Troob Family Foundation, on loan to the Sterling and Francine Clark Art Institute, Williamstown, Massachusetts)

Page 30: Detail of *View from the Château de La Faloise,* 1856 (Canadian Centre for Architecture, Montreal)

Page 46: Detail of *Château de La Faloise, Late Afternoon,* 1856 (Private collection, New York)

Photography Credits

Studio Monique Bernaz, Geneva: fig. 37
Photograph by James A. Ganz: fig. 10, pp. 76–77
© The Metropolitan Museum of Art, New York: figs. 23 and 38
Musées de Strasbourg, E. Bacher: fig. 26
Photograph © 2007 Museum of Fine Arts, Boston: fig. 2
© Philadelphia Museum of Art: figs. 27 and 28
Réunion des Musées Nationaux / Art Resource, N.Y.: figs. 1 (photo by C. Jean) and 7
© Sterling and Francine Clark Art Institute, Williamstown, Massachusetts: figs. 3–5, 13, 14, 17–19, 21, and 36

Contents

Preface and Acknowledgments

This publication grows out of an exhibition organized and presented at the Sterling and Francine Clark Art Institute in the fall of 2003 entitled *Édouard Baldus: Landscape and Leisure in Early French Photography*. The Clark had acquired a remarkable Baldus photograph of the Château de La Faloise in 1998, at the beginning of a new initiative to develop a collection of early photography. By 2002, the museum had acquired two more of these intriguing photographs, and I had become fascinated by this little-known project carried out by one of the greatest masters of early French photography. I grew determined to reassemble the estranged prints, now scattered in collections in the United States, Canada, and France, and to arrive at an understanding of the artistic process and what went into making these masterpieces. Seeing the photographs together for the first time in Williamstown was a revelatory experience that facilitated many of the observations in this book.

This publication would not have been possible without the generous support and encouragement of numerous people. I offer my thanks to Jill Quasha and Paul Katz for introducing me to the subject in 1998. Valuable research assistance was provided by Anne-Sophie Fauquet, working under the direction of Anne de Mondenard of the Médiathèque de l'architecture et du patrimoine. The following colleagues and collectors facilitated my study of Baldus's work and provided key loans to the exhibition held at the Clark in 2003: Pierre Apraxine, Sylvie Aubenas, Jean-Charles Cappronnier, Remi Cariel, Jean Caty, Clément Chéroux, Mikka Gee Conway, Marie-Laure Crosnier-Leconte, Malcolm Daniel, Mary F. Daniels, Louise Désy, Marie-Anne Dupuy, Daniel Girardin, Manon Gosselin, Anne E. Havinga, Mark Haworth-Booth, Françoise Heilbrun, Jean-François Heim, Judith Hochberg, Charles Isaacs, Deborah E. Kraak, Hans P. Kraus, Jr., Patrick Lamotte, Thierry Laps, François Lepage, Gérard Lévy, Laure de Margerie, Lee Marks, Paul Martineau, Michael Mattis, Olivier Meslay, Michel Minotte, Sylvain Morand, Katrina Newbury, Leslie Paisley, David W. Rickman, Innis Howe Shoemaker, Howard Stein, Sam Stourdzé, David and Tara Troob, and Katherine Ware. For believing in this project from the beginning I wish to thank the Clark's director, Michael Conforti. I am also grateful to a number of current and former staff members at the Clark for helping me realize the exhibition and publication: Michael Agee, Brian Allen, Merry Armata, Harry Blake, Karen Bucky, Jennifer Cabral, David Cass, Paul Dion, Lisa Dorin, David Edge, Keith Forman, Katherine Pasco Frisina, Lindsay Garratt, Diane Gottardi, Mari Yoko Hara, Sherrill Ingalls, Mattie Kelley, John Ladd, Barbara Lampron, Monique LeBlanc, Sarah Lees, Jacob Lewis, Jim Moran, Saul Morse, Richard Rand, Mark Reach, Susan Roeper, Curtis Scott, Nancy Spiegel, Katie Steiner, and Noël Wicke.

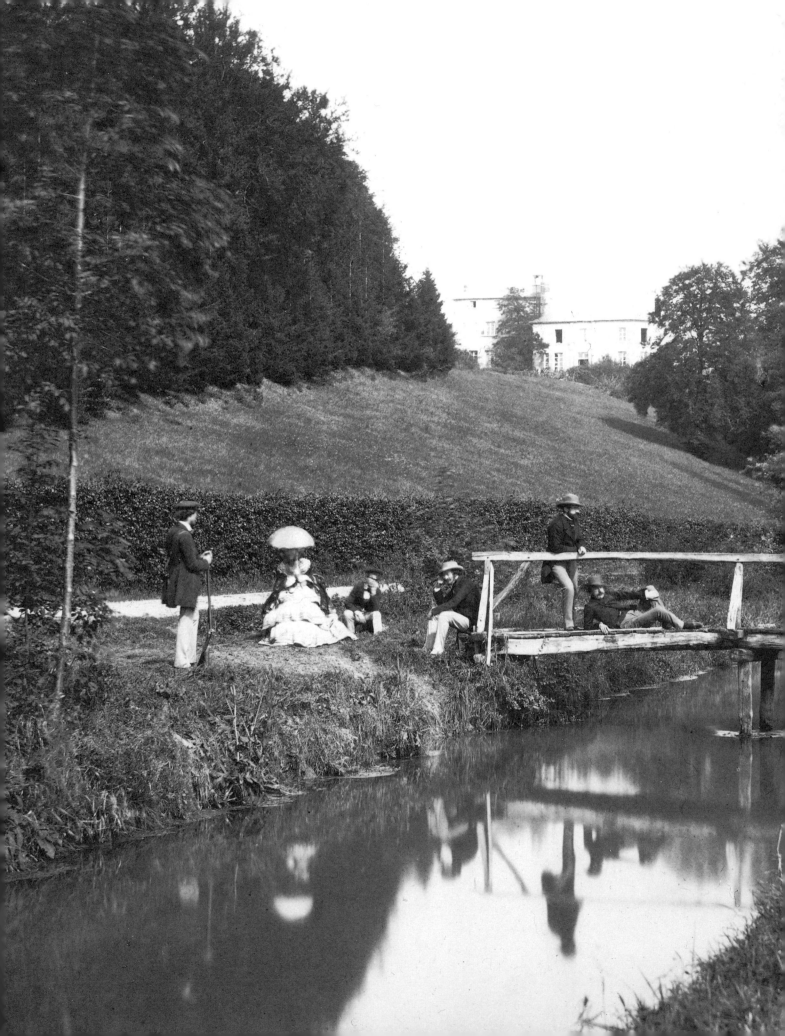

A Group in a Park

A photograph is only a fragment, and with the passage of time its moorings come unstuck. It drifts away into a soft abstract pastness, open to any kind of reading.

—Susan Sontag (1977)

It is not known precisely how or when the great collector Georges Sirot came to possess a unique cache of photographs by Édouard Baldus (1813–1889) of a private château in the French countryside. One of the earliest connoisseurs of French photography, Sirot (1898–1977) formed a vast collection during the mid-twentieth century, at a time when nineteenth-century photography was not yet widely appreciated.[1] Many of his discoveries were made in the legendary Parisian flea markets—the Puces—that still flourish on weekends near the Porte de Clignancourt and the bordering streets of Saint Ouen. Sirot spent years trolling the Puces, searching for fragments of a lost age, the world of Napoléon III and the Second Empire. It was through the music of Chopin, the novels of Sand, and the photographs of Nadar, Marville, and Baldus that Sirot happily immersed himself in this bygone era.

The works that are the focus of this study were probably acquired by Sirot after he sold and partially donated his enormous photography collection to the Bibliothèque Nationale de France in 1955. Some two thirds of the original Sirot collection consisted of anonymous family photographs from albums that he had salvaged from the flea markets. Given his fascination with Second Empire portraiture, one can only imagine Sirot's pleasure in Baldus's quintessential images of a day in the life of an haut-bourgeois family at their country house. Sirot undoubtedly appreciated the artistry of these photographs, but even more, their evocation of a lost age for which he harbored an insatiable nostalgia.

During the late 1960s Sirot began placing this extraordinary group of photographs into circulation, selling or trading individual prints with his friends and followers Gérard Lévy, François Lepage, Hugues Autexier, and François Braunschweig (the latter partners operated the legendary Galerie Texbraun). Since then, the photographs have made their separate ways

into museums and private collections in Paris, Strasbourg, Montreal, Philadelphia, New York, Boston, and Williamstown. In time, these evocative and haunting works have tantalized generations of photography collectors, curators, and historians, while contributing to the elevation of Baldus's status as an artist-photographer of the first rank. Pierre Apraxine has credited one of these prints with inspiring Howard Gilman to concentrate his collecting efforts on nineteenth-century photography: "For us it all started with discovering Baldus's photograph of an afternoon in the country. I didn't know who Baldus was, but when you see something extraordinary like that, if you've been studying art for some time, you just know it is an over-looked masterpiece."[2]

The public reemergence of Baldus's photographs of the Château de La Faloise began in 1969, with the publication of the Musée Kodak-Pathé's *Présence de la photographie,* which reproduced a salted paper print depicting an artfully arranged group of a woman and five men at a footbridge (fig. 1).[3] Vaguely evocative of a distant time and place—a relaxed Sunday, perhaps, somewhere in the French countryside—this untitled, undated, and unsigned photograph was given the descriptive caption *Promenade dans un parc* on the occasion of its first publication. Its attribution to Baldus, one of the fore-most French photographers of the 1850s, was based on an inscription by Sirot, stating that he had in his collection a duplicate print bearing the artist's facsimile signature stamp.[4]

In 1978, when the photograph appeared again in the American traveling exhibition *The Second Empire: Art in France under Napoleon III,* it was entitled *Group in a Park* and dated to about 1853. In the catalogue entry, charged with describing an object stripped of its historical context, Eugenia Parry concentrated her discussion on formal analysis:

The picture offers a lesson in photographic composing while it demonstrates some formal conventions of Impressionism evolved by the photographers of the 1850s. Baldus carefully framed his image to balance the dark conifers on the left with the poplars on the right. The figures are placed so as to create a horizontal arrangement in keeping with the shape of the photograph. The sense of nature under the control of the landscape gardener is made explicit by the photographer's having synthesized the motif, thus more fully expressing the refined charm of the locale. As he calculated the arrangement, Baldus must have counted on the houses in the distance to sustain interest against the superb reflections in the stream.[5]

At the end of her entry, Parry noted the existence of a second print of a similar subject, a "variant" acquired by the Philadelphia Museum of Art in 1970 featuring another view of the footbridge with several of the same figures posed in a different configuration (see fig. 27). A signature stamp on the Philadelphia photograph corroborated Sirot's annotation on the Kodak-Pathé print, confirming its attribution to Baldus.

In 1982, a pair of related photographs then in two private collections surfaced in the exhibition *Visions of City and Country: Prints and Photographs of Nineteenth-Century France,* organized by Bonnie L. Grad and Timothy A. Riggs.[6] "At first glance [*Group Portrait at the Château de La Faloise* (fig. 2)] is a somewhat puzzling photograph," the authors mused:

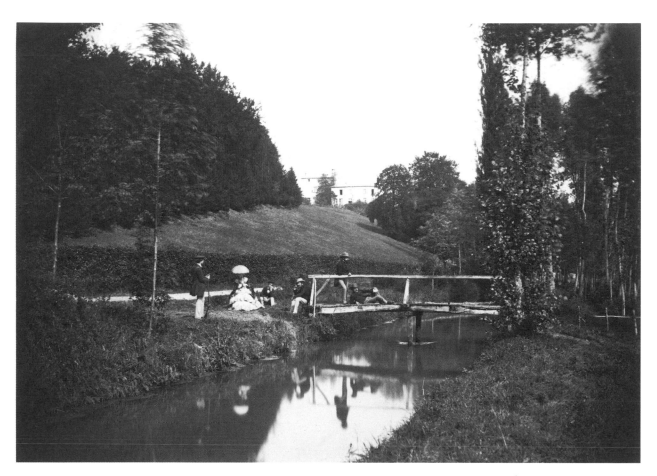

Fig. 1. Édouard Baldus, *Footbridge at La Faloise I,* 1856
Salted paper print from wet-collodion-on-glass negative, 11⅜ x 16 in. (29 x 40.8 cm)
Musée d'Orsay, Paris. Gift of the Kodak-Pathé Foundation

Four men and a woman are posed in the open air, but their distance from the photographer is such that the image is not immediately definable as a portrait. Yet they are not mere staffage in a landscape. The landscape itself is a large expanse of lawn bordered by trees with an unidentifiable structure at the right. A second photograph by Baldus [fig. 21] clarifies the situation. The structure is part of a country house, and the lawn is part of its extensive and well-kept grounds. This is openly a portrait of a piece of property.[7]

Grad and Riggs made an important contribution to our understanding of these images, but fundamental questions remained concerning the identity of the sitters, their geographical setting, and the significance of this unusual project within Baldus's vast œuvre.

In 1983, the Kodak-Pathé Foundation donated its *Group in a Park* to the Musée d'Orsay, along with 1,200 other

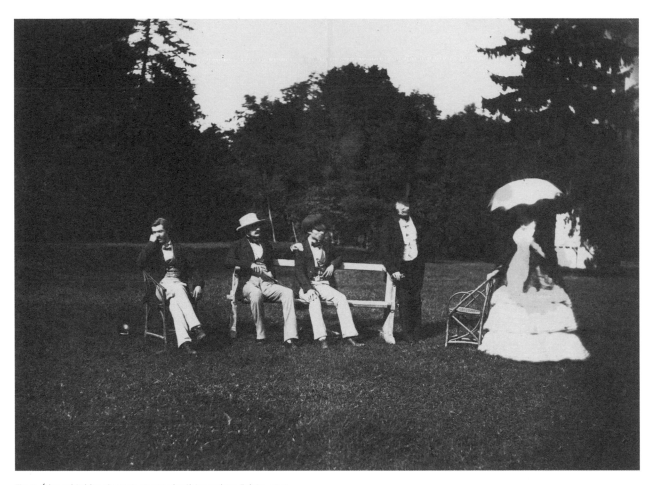

Fig. 2. Édouard Baldus, *Group Portrait at the Château de La Faloise,* 1856
Salted paper print from wet-collodion-on-glass negative, 11 ⅝ x 15 ¾ in. (29.4 x 40 cm)
Private collection. Courtesy Museum of Fine Arts, Boston

early French photographs. Subsequently Françoise Heilbrun entered the discourse on the formal affinities between Baldus's photographs and Impressionist painting. In the "series of a group of figures in a park," she wrote in *A Day in the Country: Impressionism and the French Landscape* (1984), "the all but audible rustle of the trees, the random details—a rowboat, a parasol—connoting leisure, and, most important, the lack of depth highlighted by the mirror image in the water below all make for a true form of Impressionism in the spirit of Monet's *On the Seine at Bennecourt.*"[8] Heilbrun's publication *Les paysages des impressionists* (1986) expanded on this theme and at last identified the photograph's setting: "Standing before certain landscapes by Baldus dating from 1855, such as the *Group in the Park of La Faloise*, one can't help but think that they offer the synthesis of all that the photographic vision could bring to an entire generation of artists and notably to the 'modern painters' of the 1860s, that is, the Impressionists."[9]

At the same time, in his groundbreaking work on Baldus starting in the late 1980s, Malcolm Daniel made strides

The Château

Everyone, with the help of the Daguerreotype, will make a view of his château or his country house.

Louis-Jacques-Mandé Daguerre

Located in Picardy, some fourteen miles south of Amiens, the tiny village of La Faloise takes up just 3.7 square miles, and today numbers little more than two hundred inhabitants (fig. 3). It occupies an elevated plain rising above a fertile valley traversed by the Noye River and the great Northern Railway *(Chemin de fer du nord)*. During the bloody Battles of the Somme, La Faloise was awakened from its peaceful existence and in 1918 was briefly occupied by American troops.[15] Despite heavy shelling, the village managed to escape the architectural devastation that much of this region endured.

In a geological sense, an ancient tie between France and England supports the foundation of the Château de La Faloise, for prior to the last Ice Age, the chalk cliff (*falaise* in French) upon which the village sits was amalgamated with the cliffs of southern Britain. The château occupies a site that has been inhabited since at least the early fourteenth century, a strategic vantage point along the *chemin des Anglais,* the ancient "road of the English" extending north from Paris to Amiens. The earliest documented structure on this site was a fortress belonging to Jean II de Montmorency, Lord Beaussault (d. 1373). His house was one of countless châteaux destroyed during the Jacquerie, a peasants' rebellion that swept through the countryside in the summer of 1358. The château was apparently rebuilt during the early fifteenth century, but after successive occupation by the English and the dukes of Burgundy, both warring against the French crown, it was described again as in ruins in a census of 1462.[16]

The only surviving portion of the château to reflect its late medieval origins is a square tower flanked by four hexagonal turrets and pierced by a great vaulted passageway (fig. 4). Dating from the fifteenth century, this stone *donjon* presumably functioned as a gatehouse, its turrets placed so as to defend the arched entry. For the next three hundred

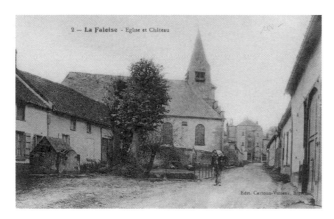

Fig. 3. *La Faloise—Eglise et Château,* c. 1910
Collotype (postcard published by Cartoux-Vimeux), 3 ½ x 5 ½ in. (8.9 x 13.9 cm)

years, control of the Château de La Faloise and its domain passed from one aristocratic family to another.[17] It was apparently not maintained as a primary residence, and in 1772, the superintendent of the estate urged the demolition of the building, reporting it to be uninhabitable by the lord of the manor.[18]

The château was spared, however, and in 1793 it came into the possession of Alexandre-Joseph Debray, a merchant from Amiens.[19] Three years later, Debray was recorded as a witness at the marriage ceremony of Marie-Anne-Hélène-Elisabeth Dottin (1775–1840), daughter of another Amiens merchant, and the German-born Louis-Frédéric Bourgeois Demercey (1762–1850). The latter couple would acquire the château from Debray and undertake major renovations during the early nineteenth century. They added a new two-story *logis* to the east of the tower, in the area where a detached building had been described in the late seventeenth century (fig. 5). Visible in one of Baldus's photographs is the year "1827" emblazoned on the tower's southern roof (fig. 6), commemorating its replacement as part of the restoration project. The nineteenth-century edifice was oriented with its principal façade overlooking a private park sloping down toward the Noye River valley. With its back to the village, the château settled into its function as a place for rest and relaxation away from civilization: a proper, if modest country house for city dwellers.

Demercey and his wife had two children: a son, Frédéric, born in Paris in 1803, and a daughter, Elisabeth-Geneviève, who married the military commander François-Alexandre Desprez and spent most of her life in Brussels.[20] When Frédéric was three years old, his father was named General Administrator of the Domain of the Empire in Italy. Little is known of his father's activities in this capacity, other than introducing the cultivation of indigo to Naples. He was made a

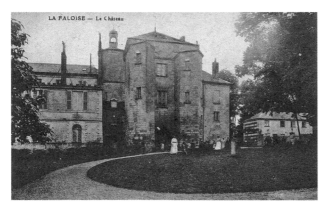

Fig. 4. *La Faloise—Le Château,* c. 1910
Collotype (postcard published by Cappe) 3 ⅜ x 5 ⅜ in. (8.7 x 13.8 cm)

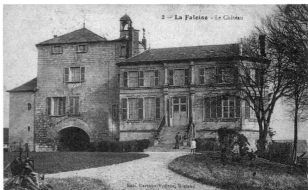

Fig. 5. *La Faloise—Le Château,* c. 1910
Collotype (postcard published by Cappe) 3 ½ x 5 ½ in. (8.7 x 13.8 cm)

count in 1813, and after the fall of Napoléon, returned with his family to Paris.[21] From his father, Frédéric would inherit a love of travel and cultivation of the arts, and from his mother, a house in the country where he could write, draw, and escape the metropolis.

In 1840, upon the death of Madame Demercey, her son took possession of the Château de La Faloise and its extensive grounds. Valued at 470,000 francs, the property was inventoried as follows:

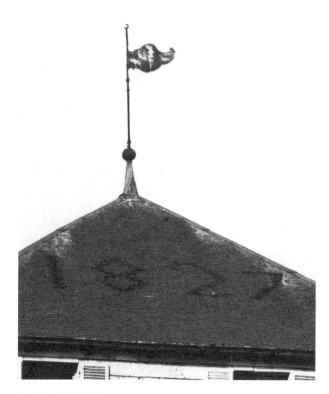

Fig. 6. Detail of fig. 22

1. The château, courtyard, poultry yard, park, garden, meadow, fertile land, woods and sheds: all of this forming one mass.

2. Five hectares [twelve acres] of woods.

3. Two portions of woods, said to be unclaimed, at Paillart and found to the right and the left of the Chemin de Beauvoire toward the fields, and a small portion of dry land with paving stones, upon which is planted an avenue of elms.

4. A grain mill, located at the entrance to the village, with a courtyard, garden and out-buildings, bordered on one side by the river and on the other by the village.

5. An oil and fulling mill located on the other side of the river with a courtyard and out-buildings, and a garden of the area of thirteen ares thirty centiares [approximately one third of an acre]; the aforesaid mill bordered by the river and a meadow called the great meadow.

6. Ten hectares of land [approximately twenty-five acres] along the river, mainly in the great meadow.

7. Diverse pieces of fertile wooded land, not contiguous with the preceding portions.[22]

With the construction of the Northern Railway line from Paris to Boulogne via Amiens, the tiny medieval hamlet found itself connected through the expanding rail network with the rest of France. The journey time from Paris to La Faloise was reduced from the full day required by road travel to little more than two hours by rail. Rising above the valley on the edge of the village, the château became a landmark. A local historian wrote around 1900, "What traveler from Amiens to Paris hasn't noticed, shortly before greeting the picturesque château de Folleville, a white habitation half-concealed by the thick foliage of a park? It is the château de La Faloise."[23] Just as the *Chemin de fer du nord* facilitated its Parisian owners' excursions to their house in the country, so too did it bring one of the most famous Parisian photographers to their doorstep.

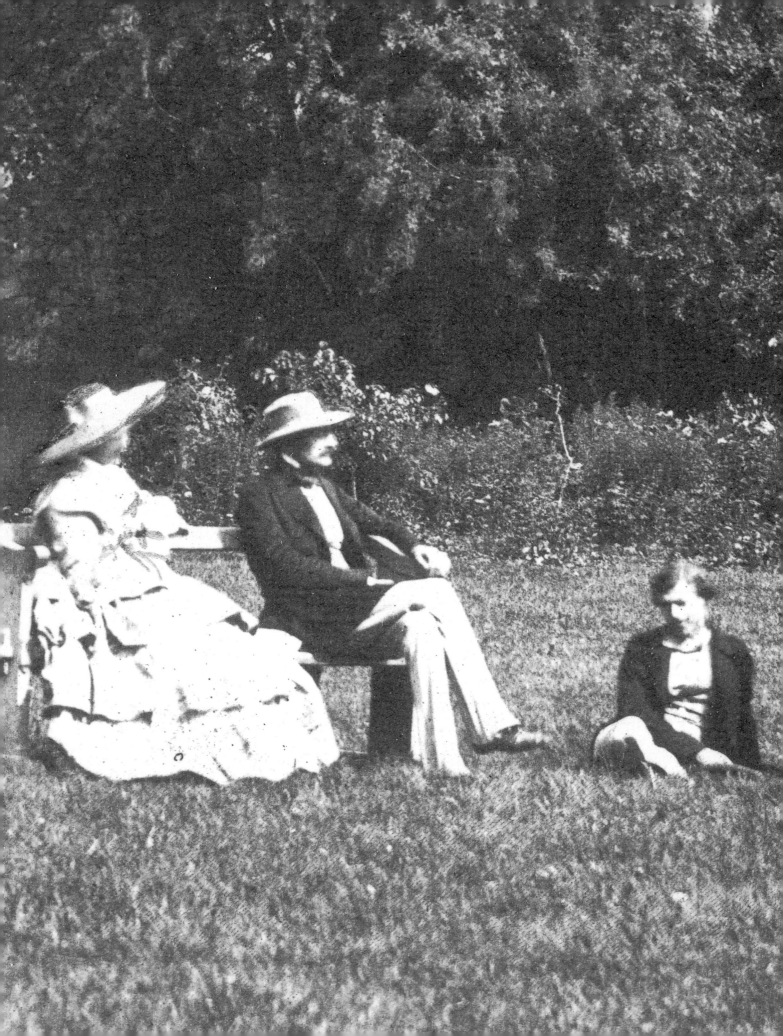

achieved a fluency of form and refined palette characteristic of Bertin's best work[...]

he devoted considerable energy to publishing a series of self-illustrated travel b[...] (Tiel, the Prowler), in 1834. Beginning in 1837, de Mercey's art criticism appeared [...] pseudonym "La Genevais."[31]

De Mercey settled down after marrying an Englishwoman named Anna [...] Fields, London, in 1837, and fathering twin sons, Napoléon-Frédéric and Albert Ch[...] the age of thirty-eight, de Mercey received his initial government appointment as h[...] then under the control of the Ministry of the Interior. In this role he became an influ[...] official commissions for the decoration of public buildings and developed persona[...] artists of the day.

De Mercey made the acquaintance of Eugène Delacroix after favorably [...] *Revue des Deux Mondes*.[32] They became frequent dining companions during the 184[...] awarding Delacroix a number of public commissions, including the decorations fo[...]

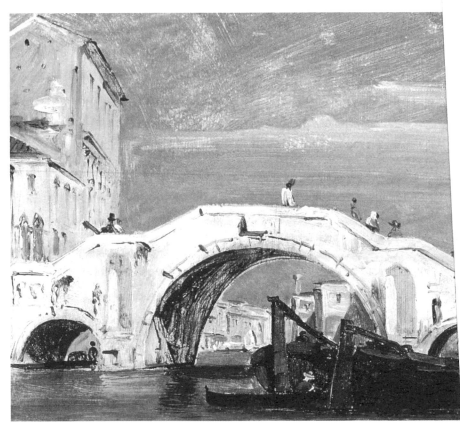

Fig. 8. Frédéric Bourgeois de Mercey (French, 1803–1860), *A Bridge in Venice*
Oil on paper laid down on canvas, 6 ¾ x 10 ¼ in. (17 x 26 cm)
Galerie Jean-François Heim, Paris

A Forgotten Public Figure

The fundamental belief in the authenticity of photographs explains why photographs of people no longer living and of vanished architecture are so melancholy.

—Beaumont Newhall

Frédéric Bourgeois de Mercey, the owner of the Château de La Faloise, was an important patron of Baldus (fig. 7). Some acquaintance with this forgotten government official is necessary in order to understand the photographer's particular sensitivity to his client in staging the views of his château. Before a small family chapel on the outskirts of La Faloise, Jacques Ignace Hittorf, the architect of the Gare du Nord, delivered de Mercey's eulogy on 10 September 1860.[24] The journal *l'Artiste* recorded his moving tribute:

In his long administrative career, Monsieur de Mercey devoted his existence to furthering the noble enthusiasms of His Excellence. His constant preoccupation was the fear of not living up to this difficult task. Moreover, the sleepless nights, the sacrifices, an absolute devotion to his work: he spared nothing toward the great project of upholding our arts to the supremacy that contributes so much to the glory of France.

The knowledge of having fulfilled his tasks, the certainty of having done only his best and of being appreciated by the Minister [of State, Achille Fould], his worthy commander, who throughout the painful malady of Monsieur de Mercey, gave him so much sympathy and affection: all of these great consolations helped our friend to sustain his long suffering with the resignation of a fine and Christian soul. Nevertheless, how heartrending his final moments must have been to his completely devoted consort, and to his two beloved sons whom he leaves grieving! Deprived of the head of the family who meant

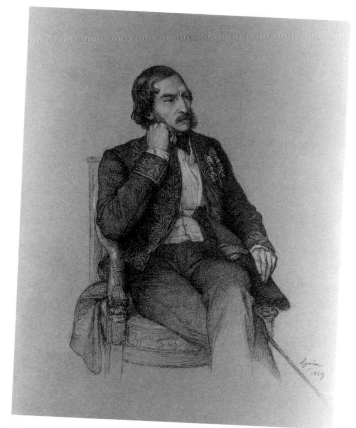

Fig. 7. François-Joseph Heim (French, 1787–1865), *Portrait of Frédéric de Mercey*, 1859
Black chalk touched with white chalk on gray paper, 16⅛ x 11⅜ in. (41 x 29 cm)
Musée du Louvre, Paris

everyth

sorrow

the gen

of Monsi

widow, a

influence

The servic

emony at

high gove

of the Aca

Blanc prai

matic skills

wasn't an a

not an exh

quality that

didn't knov

effused.[26] In

and passion

scape painte

all who knew him, and his name will not be erased from the list of remarkable m

A bureaucrat's fame is fleeting, however. With the passing of generatio
ered dust on library shelves, most of his paintings have been lost,[28] and his life's acc
Figures like de Mercey who represented the Establishment in mid-nineteenth-cen
to historians than the artists who struggled to work inside and, increasingly, outsi
in which networking skills could be as important as talent, Frédéric de Mercey
determined which painters, sculptors, architects, and photographers would receive
commissions.

During the 1830s, de Mercey lived the life of a well-to-do *flâneur*, while es
and essayist. He studied with the historical landscape painter Jean-Victor Bertin (1
sketchbooks with views of Italy, Austria, Bavaria, the Low Countries, and Scotland.[2]
with views of Venice and Switzerland, and exhibited in every Salon through 1841, g
scape in 1838. A group of his Italian plein-air oil sketches that recently appeared

Photographer and Patron

The true content of a photograph is invisible, for it derives from a play, not with form, but with time.

—John Berger

In the mid-1850s, leading French photographers banded together in an intense campaign to elevate the status of photography from an industrial marvel to an art form, and the most talented photographers of the decade—Baldus, Gustave Le Gray, Charles Nègre, Charles Marville, the Bisson brothers, and Nadar—had only just begun to push the medium to the truly staggering heights that it would attain. The installations of photographs at the Exposition Universelle, and the first two exhibitions of the French Photographic Society of 1855 and 1857, provided important public forums for open debate on the matter of photography's acceptance into the Salon of fine arts.

As an artist and arts administrator, Frédéric de Mercey would have been well aware of the current debates over the status of photography. He was a member of the Historic Monuments Commission that in 1851 sent Baldus and four other photographers on *missions héliographiques* to document architectural monuments all over France.[39] De Mercey was one of two members of the commission to join the Société héliographique (Heliographic Society) upon its formation in January 1851. Other founding members included Baldus, Le Gray, Delacroix, and the critics Champfleury and Francis Wey. A quarter-plate daguerreotype of a man reading a letter in his study (fig. 11), dating to 1850–51 has recently been identified as a portrait of de Mercey and attributed to Baron Jean-Baptiste-Louis Gros, the society's first president.[40]

The records show that de Mercey was an active participant in the Heliographic Society. At one of its earliest meetings, in February 1851, he was present for a demonstration by Hippolyte Bayard and Ernest Cousin of a *découpage* technique to facilitate the inclusion of clouds in the normally blank skies of landscape photographs. In his report of the meeting, Benito de Montfort noted, "Monsieurs Bayard and Cousin presented to the Heliographic Society skies that provoked the astonishment of artists, of whom M. de Mercey, the illustrious landscapist, was notable for his admiration and the praise with which

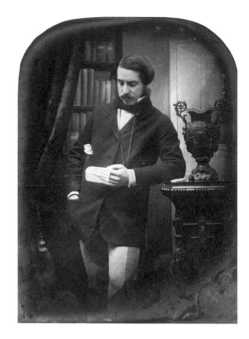

Fig. 11. Baron Jean-Baptiste-Louis Gros (French, 1793–1870), *Portrait of Frédéric Bourgeois de Mercey,* 1850–51 Daguerreotype, quarter plate, 4¾ x 3⅜ in. (12 x 8.5 cm) Bibliothèque nationale de France, Paris. Gift of Georges Sirot

he honored these gentlemen. Such processes intimately connect photography to the fine arts."[41]

Unfortunately, we have neither memoirs nor correspondence detailing the personal relationship between de Mercey and Édouard Baldus (fig. 12), though records of the Administration of Fine Arts show that the photographer enjoyed favored treatment from de Mercey's office during the 1850s. After receiving three commissions to copy paintings in the Louvre, Baldus was awarded government support for an ambitious project that he called *Villes de France photographiées.* He was also hired to produce facsimiles of Jean Lepautre's ornament prints (1853), and to document architectural monuments in the Midi (1853), the construction of the new Louvre (1854–), the floods in Lyon and Avignon (1856), and an imperial visit to Normandy (1858). On his own, Baldus initiated a series of photographic reproductions of contemporary paintings in 1854. Writing in *La Lumière,* Ernest Lacan singled out for praise Baldus's photograph of one of de Mercey's oils:

> We have seen him finish before us one of his reproductions, a charming landscape of M. de Mercey. The extreme delicacy of the leafy oaks that cover the greater part of this beautiful canvas, the luminous sky that appears in thousands of spots between the branches, the transparent water in the foreground, the vaporous background, all of these contrasts so necessary for the effect, but so unfavorable to photographic reproduction, have all of their value and their charm in Baldus's print.[42]

It was another of Baldus's major projects of the decade, the *Chemin de fer du nord* album of 1855, that brought him to the vicinity of de Mercey's country house at La Faloise. The album, *Visite de sa majesté la reine Victoria et de son altesse royale le Prince Albert 18–27 août 1855: Itinéraire et vues du Chemin de Fer du Nord,* was commissioned by Baron James de Rothschild, the railroad's president, for presentation to Queen Victoria and Prince Albert upon their visit to the Exposition Universelle. The album includes some of Baldus's most ravishing architectural and landscape subjects, as well as his atmospheric marine photograph, *Entrance to the Port, Boulogne* (fig. 13), marking the point of embarkation. In addition to this prestigious commission, Baldus won a first-class (silver) medal for his submissions to the Exposition. It is fair to say that in 1855 he had reached the pinnacle of his profession.

Although photography was fit for the queen's album, the organization of the Exposition Universelle reflected the government art administration's refusal to acknowledge photography as a fine art. In setting out its official decrees and bylaws, the imperial commission overseeing the plans for 1855 was careful to differentiate the "Exhibition of Industry and

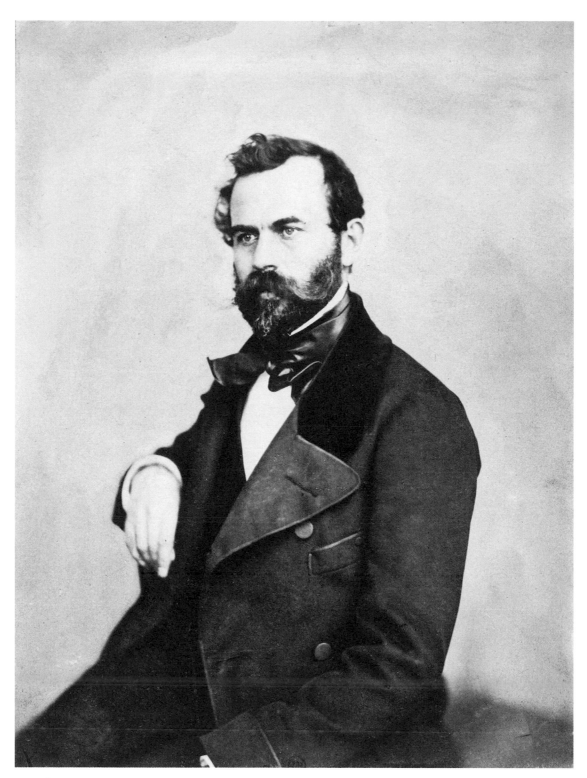

Fig. 12. Édouard Baldus, *Self-Portrait,* 1853
Salted paper print from paper negative, 8 x 6 ⅛ in. (20.3 x 15.4 cm)
Bibliothèque nationale de France, Paris

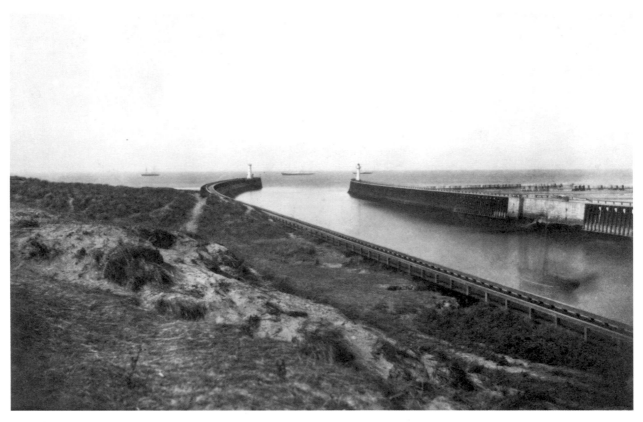

Fig. 13. Édouard Baldus, *Entrance to the Port, Boulogne,* 1855
Salted paper print from paper negative, 10 x 16 in. (25.4 x 40.6 cm)
Sterling and Francine Clark Art Institute, Williamstown, Massachusetts

Agriculture" and the "Exhibition of Fine Arts," which would take the place of the Salons of 1854 and 1855. Article 16(1) states

that "the products will form two distinct divisions: *products of industry* and *works of art.*" Photography was placed in Division

I (Products of Industry), Group VII (Furnishing and decoration, fashion, industrial design, printing, and musical instruments),

Class 26 (Drawing and plastic arts applied to industry, printing in relief and intaglio, photography).[43] So while photographs

were shown in the Palais de l'Industrie alongside fans and costume jewelry, the fine arts of painting, sculpture, watercolor,

metal and wood engraving, lithography, and architecture were installed in Lefuel's Palais des Beaux-Arts on the nearby

avenue Montaigne. In the case of Charles Nègre, this organizational scheme meant that his paintings submissions were

shown in one venue, while his photographs were relegated to another; one of Nègre's paintings, a genre scene of an organ

grinder, was based on his photograph of the same subject on view simultaneously in the Palais de l'Industrie.[44]

Agitating for official recognition, which meant nothing less than the admission of photography into the biannual

fine art salon when it resumed in 1857, the members of the recently formed Société française de photographie (SFP)

staged their own group shows beginning in 1855. Baldus became a member of this organization at the time of its second

exhibition, which was set to open in the fall of 1856 but was delayed until January 1857.[45] The delayed opening came about

both to allow the participants ample time to print their negatives from their most recent summer campaigns and to facilitate the relocation of the exhibition from the society's cramped rooms at 11, rue Drouot, to 35, boulevard des Capucines.[46] The latter address housed the spacious photography studios of Gustave Le Gray and the Bisson brothers. The jury of admission included Count Olympe Aguado, Hippolyte Bayard, Eugène Delacroix, Léon de Laborde, Philippe Rousseau, Gustave Le Gray, and Louis Robert.[47] The popular success of the photography exhibition was reported in the society's *Bulletin*,

Fig. 14. Gustave Le Gray (French, 1820–1882), *Brig on the Water*, 1856
Albumen print from wet-collodion-on-glass negative, 12⅝ x 16¼ in. (32.07 x 41.28 cm)
Sterling and Francine Clark Art Institute, Williamstown, Massachusetts

and its closing date was extended from February to May 1857.

With a historical section of photographic incunabula by Joseph-Nicéphore Niépce, Louis-Jacques-Mandé Daguerre, William Henry Fox Talbot, and Bayard (among others), more than a hundred French exhibitors, and a strong showing from British and other foreign photographers, the SFP exhibition of 1857 was a major event. Le Gray exhibited his *Brig on the Water* (fig. 14), Nègre showed Pifferari studies and heliographic engravings, Marville presented cloud studies, Nadar submitted a selection of celebrity portraits, and Roger Fenton showed some twenty-five recent prints from collodion negatives. Baldus's submissions consisted of four views of the Louvre from collodion negatives, two scenes of the Lyon floods from paper negatives, and from a collodion negative, a single view of the Château de La Faloise, the first and last time a print from this series was placed on public view for more than a hundred years.[48] Although the display of this object passed unnoticed by the press, we might speculate that its inclusion in this venue represented a calculated attempt on Baldus's part to attract the attention of his most important patron to this momentous exhibition.

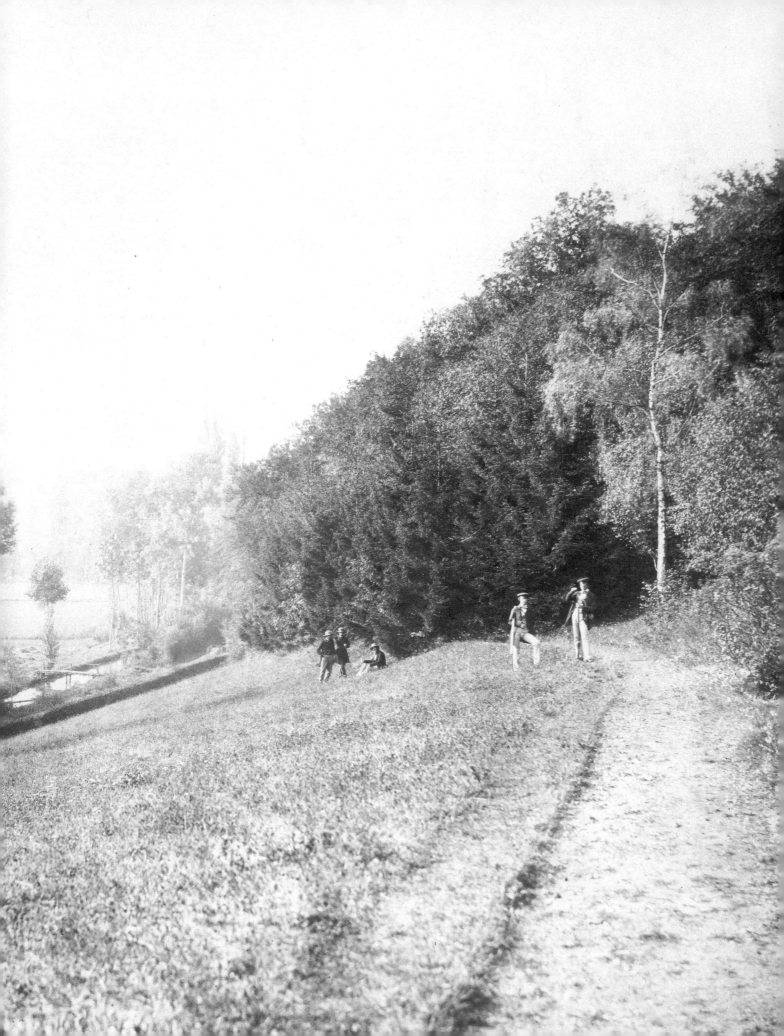

A Day in the Country

People have previously found many activities with which to distract themselves during the days of tranquility, and at times, monotony, which are spent in the country, but they have not yet considered photography.

—Ernest Lacan (1857)

Ernest Lacan's text "Photography in the Countryside," reproduced as an appendix to this volume, describes a scene of intense anticipation surrounding the visit of a traveling photographer to a client's château during the mid-1850s. One can imagine a similar state of excitement prevailing at Frédéric de Mercey's country house on the occasion of Édouard Baldus's visit in 1856. The photographer would have arrived in the company of at least one assistant to help in transporting his equipment and processing his negatives on-site, just as he is known to have employed an assistant in June 1856 to photograph the devastation wrought by the floodwaters in the Rhône Valley.[49] The conditions at La Faloise were considerably more favorable, and it is entirely possible that Baldus carried out his work there during the course of a single day. The camera placements are not widely dispersed, and the various sitters appear to be wearing the same clothes throughout the different views. By scrutinizing the lighting conditions and the direction of the shadows, one can construct a speculative timeline, placing the photographs in a sequence from early morning to late afternoon.

By 1856, Baldus was proficient at using the newer medium of wet-collodion-on-glass in the production of his negatives, although he had not abandoned the paper negative process. There is some disagreement in the literature concerning the type of negative he employed at La Faloise, despite the notation in the SFP exhibition catalogue of 1857 that a collodion negative was employed for his view of the Château de La Faloise.[50] Close examination of the extant prints suggests that on this occasion he took advantage of the shorter exposure times and greater detail afforded by collodion, despite the fact that his glass-plate negatives had to be prepared and processed in a portable darkroom set up in the field, rather than

back in the relative comfort of his Paris studio. One of the negatives (see fig. 29) suffered deterioration in its collodion coating, causing a distinctive craquelure pattern to appear in the positive print.

Just as he remained flexible in his choice of negative during the mid- to late 1850s, Baldus also continued to print his negatives using the old salted paper method alongside the newer albumen silver process. In making his prints of the Château de La Faloise, he relied primarily on the softer salted paper process, toned to a purplish-brown color, which he had also incorporated for the deluxe editions of the *Chemin de fer du nord* album. While there are minor variations in the dimen-

sions of the photographs, they generally correspond to Baldus's standard "large format" and are mounted on sheets of thick white paper of roughly the same size. There is no physical evidence that any of the mounts were removed from an album. Of the thirteen known prints, only two (see figs. 26 and 27) bear the facsimile signature stamp of Baldus. They are imprinted on the mount "E. Baldus"

Fig. 15. Detail of fig. 26

(fig. 15) with a stamp that the photographer employed mainly between 1855 and 1858, suggesting that they date from same period as the negatives from which they were printed.[51] Four of the unsigned prints bear inscriptions in the hand of Georges Sirot, affirming that he possessed duplicate prints with the stamp of Baldus (fig. 16; see also the List of Photographs of the Château de La Faloise at the back of this volume), only one of which has been provisionally identified (see fig. 26).

Taken as a group, Baldus's photographs of the Château de La Faloise do not form a series with a coherent narrative but rather seem to have been conceived as nine distinct and individual compositions. In fact, bringing these works together exposes visual conundrums otherwise unapparent when the prints are examined individually.[52] The arrangement of the prints in the list at the back of this volume and in the following discussion is based on a walking tour of the site, starting with the approach from the village, progressing around to the garden façade, then descending to the bank of the Noye River that flows through the property at the bottom of the hill (fig. 17).

Fig. 16. Ink inscription by Georges Sirot on verso of *Garden Façade of the Château de La Faloise* (Sterling and Francine Clark Art Institute, Williamstown, Massachusetts); see the List of Photographs of the Château de La Faloise, pp. 71–75, 2b

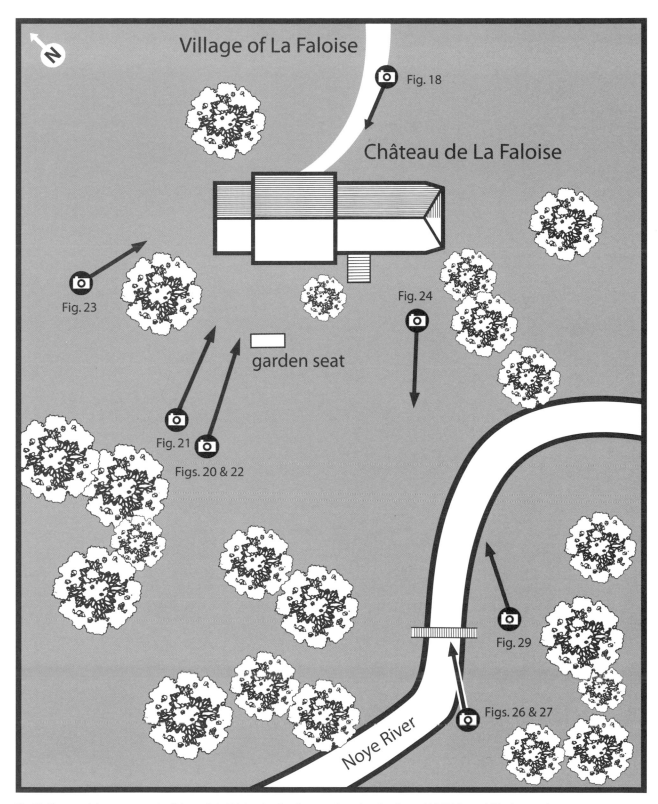

Fig. 17. Diagram of the property at the Château de La Faloise, showing the approximate locations from which Baldus took his photographs

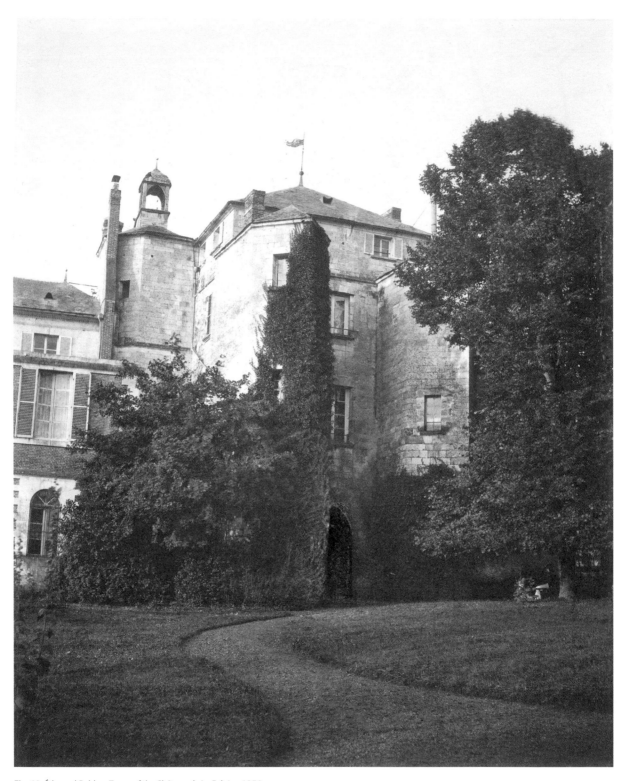

Fig. 18. Édouard Baldus, *Tower of the Château de La Faloise,* 1856
Salted paper print from wet-collodion-on-glass negative, with hand-coloring in black ink, 13⅛ x 10⅝ in. (33.3 x 27 cm)
Sterling and Francine Clark Art Institute, Williamstown, Massachusetts

The Tower

Baldus photographed the tower at an oblique angle from the estate's main point of entry, with the curving drive gently leading the viewer into the scene (fig. 18). The subject of this view, the only vertical composition in the series, is the northern façade of the oldest part of the château, the fifteenth-century tower partially shrouded with foliage. On the only known print, the tower's most distinctive feature—the vaulted tunnel passing through its foundation—is hand-inked to compensate for the loss of detail in the shadows. Although this practice was controversial at the time, Baldus frequently availed himself of retouching both in the manipulation of negatives and prints.[53] The published rules for the second exhibition of the Société française de photographie clearly forbade such measures: "Excluded from the Exposition will be all colored prints, and all of those that exhibit essential retouching that is likely to modify the photographic work, properly speaking, by substituting it with manual work."[54] In light of this restriction, it seems unlikely that this print was exhibited in 1857.

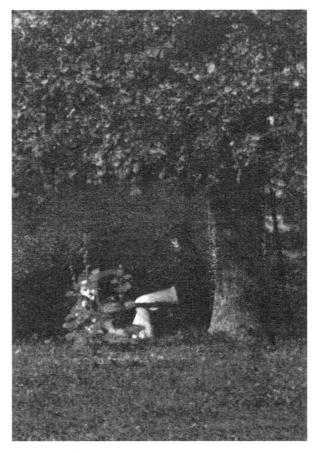

Fig. 19. Detail of fig. 18

Enlivening the composition is a partially hidden, solitary figure seated below the large tree at right, his light-colored trousers conspicuous among the shadows (fig. 19). Baldus populated many of his *mission héliographique* photographs, as well as his railway album views, with such diminutive figures. His preference for *staffage* was not as common among his countrymen as it was among contemporary English photographers. Fenton, for instance, was especially adept at enriching his picturesque architectural views through the sensitive distribution of small figures (see fig. 33). Of the French school, Count Olympe Aguado was singled out for praise by critics who admired his exceptional ability to integrate animals and human figures into his landscapes.[55]

The Garden Façade

Having passed through or around the tower, Baldus arrived at the southern garden façade of the Château de La Faloise to set up an intriguing series of three views, each staged from a similar vantage point but producing remarkably varied effects. The first (fig. 20), a nearly frontal view of the house with its door and several windows opened, is the only unpopulated photograph of the château, and as such, the most conventional: a pair of benches, to the left and in front of the tower, provide

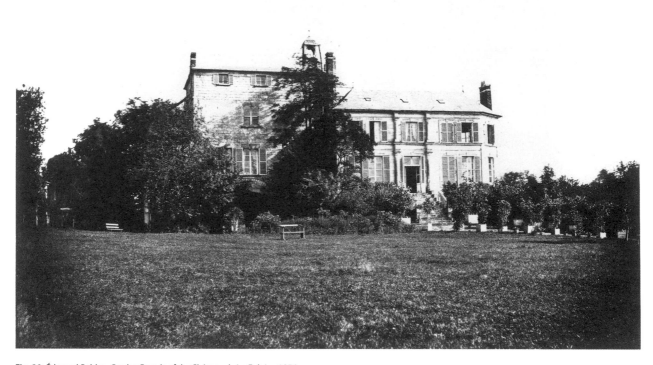

Fig. 20. Édouard Baldus, *Garden Façade of the Château de La Faloise,* 1856
Salted paper print from wet-collodion-on-glass negative, 10 ⅞ x 16 ⅛ in. (27.7 x 41 cm)
Bibliothèque nationale de France, Paris

evidence of habitation but are unoccupied. As in all of the photographs of the château, the sky is blank—a common by-product of the hypersensitivity of wet-collodion-on-glass negatives to the color blue—producing a gray tonality that was usually covered on the negative with black ink. The relatively prosaic character of this image is entirely consistent with Baldus's views in the *Chemin de fer du nord* album; its closest cognate is the plate depicting the garden façade of the château de Boran, the home of a member of Empress Eugénie's household.[56]

A second view of the garden façade (fig. 21) introduces the primary cast of characters: Frédéric de Mercey and his wife, Anna, accompanied by their sons Léon and Albert. The arrangement of the figures—husband and wife seated on a bench, one son sitting on the ground, the other standing in profile, facing them—and their central placement on the château's south lawn adheres more or less to group portrait conventions set out in painting manuals dating back two hundred years. Baldus accommodates the contradictory principles of variety of pose and compositional unity in his distribution of the group. Their relatively small scale is explained by the photograph's dual agenda, for it was not meant to operate as a simple visual rendering of the family but rather as a portrait of their lifestyle and their grand country house. The very

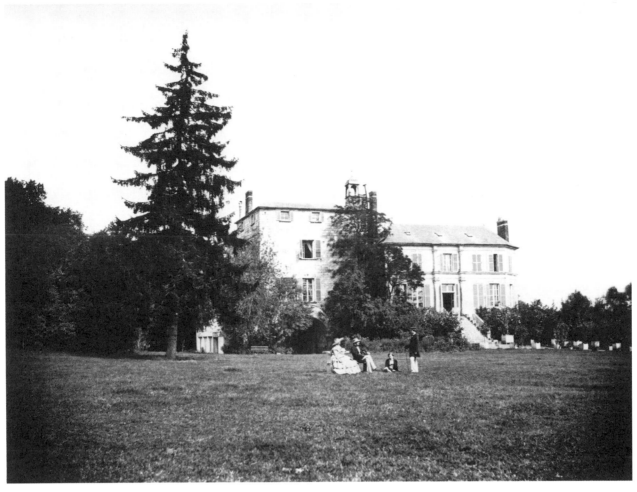

Fig. 21. Édouard Baldus, *Château de La Faloise, Late Morning*, 1856
Salted paper print from wet-collodion-on-glass negative, with retouching in pencil, 12 ⅛ x 15 ¾ in. (30.7 x 40 cm)
Sterling and Francine Clark Art Institute, Williamstown, Massachusetts

expansiveness of ground and sky and sunlight imbues the diminutive figures with a sense of supremacy, the masters of this vast private domain, far from the hustle and bustle of the city.

Counterbalancing the family group is an enormous conifer that partially obscures the tower at the left. This tree's conspicuous absence from other views of the garden façade (see figs. 20 and 22) raises the question of Baldus's manipulation of his negatives. In photographing architecture set in urban contexts, he occasionally painted out subordinate elements that might distract the viewer from his main subject. As the tree itself intrudes into the background of the group portrait (see fig. 23), there is no question that it occupied a position near the southwestern corner of the building. Its actual distance from the château is more difficult to gauge, given the subtle flattening of space in Baldus's photographs. The simplest explanation for the anomalous presence and absence of the tree is that it is farther away from the house than it appears, so that when the photographer changed the angle of view even slightly, the tree was removed from the camera's field of vision.

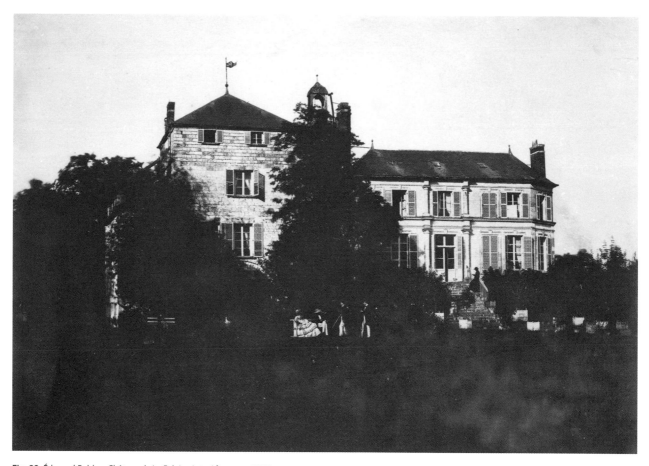

Fig. 22. Édouard Baldus, *Château de La Faloise, Late Afternoon,* 1856
Salted paper print from wet-collodion-on-glass negative, 11 ⅝ x 16 ½ in. (29.5 x 42 cm)
Private collection, New York

Baldus's third view of the garden façade (fig. 22) is a virtuoso demonstration of his ability to work under difficult lighting conditions. The family group poses at center, an unidentified man sits on a bench in the shadows at left, and a priest mounts the staircase. De Mercey's country house was not grand enough to employ its own *aumônier,* so it is likely that the priest presided at the church of Notre Dame de la Nativité, which is located just down the street. Along with Frédéric de Mercey, the village's principal landowner, the parish priest would have been the most prominent citizen of La Faloise, and his appearance in this photograph and again in the group on the riverbank (see fig. 29) is a sign of his standing in the community, as well as his close relationship to the de Mercey family.

Although the position of the shadows establishes that this photograph was made in the late afternoon, the darkness of the image was caused in part by underexposure, allowing details of the roof—including the year 1827 embedded in the slate—to appear where they were imperceptible in the previous two views (see fig. 6). The suppression of these details in figures 20 and 21 seems to have been caused by the reflection of sunlight, rather than a deliberate act of manipulation on the part of the photographer.

A Group Portrait

The setting for Baldus's plein-air group portrait (fig. 23) is an expanse of lawn to the southwest of the château, that is, roughly thirty feet to the northwest of the camera's position for figure 21. This location may be confirmed by comparing the branches of the large conifer at right with the same tree's nearly identical profile in the latter view. Behind the tree is a similar glimpse of an architectural addition to the tower's western façade. As the print in Boston (fig. 2) is slightly wider along the right edge than the Metropolitan print (fig. 23), it reveals the more distant bench visible in the other views of the garden façade (figs. 20–22). The direction of the shadows corresponds with that of figure 22, suggesting a late afternoon hour.

The group portrait (figs. 2 and 23) provides the closest view of Baldus's principal sitters: Frédéric de Mercey, Anna Morgan, their sons Léon and Albert, and a top-hatted gentleman of unknown identity. Seemingly lost in a dream, the son seated at left pretends to doze in his chair: his eyes are closed, his head is supported by his hand, and his cap has fallen on the ground. This pose, remarkable for its apparent casualness, may reflect the influence of carte-de-visite portraiture, which

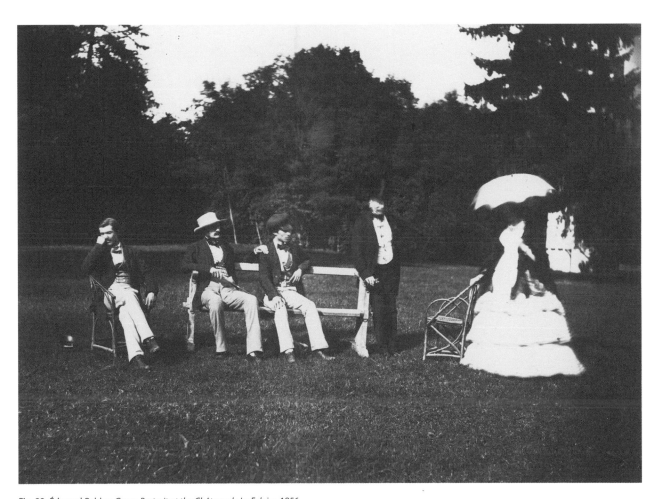

Fig. 23. Édouard Baldus, *Group Portrait at the Château de La Faloise,* 1856
Salted paper print from wet-collodion-on-glass negative, 11 x 15 in. (27.8 x 38.2 cm)
The Metropolitan Museum of Art, New York. Gilman Collection, Purchase, The Horace W. Goldsmith Foundation Gift through Joyce and Robert Menschel, 2005

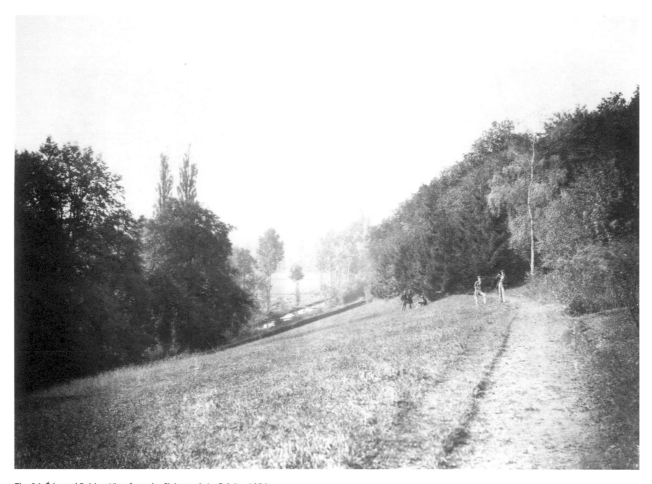

Fig. 24. Édouard Baldus, *View from the Château de La Faloise,* 1856
Salted paper print from wet-collodion-on-glass negative, 12 ⅜ x 16 ⅞ in. (31.4 x 43 cm)
Canadian Centre for Architecture, Montreal

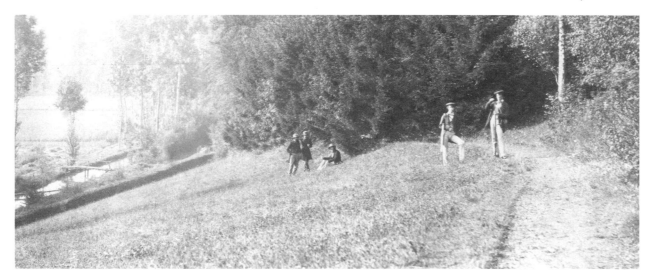

Fig. 25. Detail of fig. 24

introduced and popularized unconventional, and by contemporary standards of polite behavior, vulgar poses.[57] The other son, in deliberate contrast, sits at attention, his father's hand placed firmly on his shoulder. Both young men wear single-breasted coats, and as will become apparent in subsequent views, they are dressed for shooting of another kind.

A mysterious older man stands at the focal point of the group, propped against the stone bench facing Madame de Mercey, who appears to offer him a bentwood chair. In his English-style frock coat and silk top hat, he is the most formally attired of the group. Malcolm Daniel proposed that this figure is none other than Baldus himself, posing alongside his patrons. As attractive as this theory appears, it is difficult to imagine that Baldus would have inserted himself so prominently in this family group portrait. Furthermore, an experienced photographer would have known better than to move his head during the course of a long exposure. Daniel was unaware of another view of this group, to be discussed below, in which the top-hatted man reappears in sharp focus. A comparison of his face with the two known self-portraits of Baldus forces us to abandon Daniel's theory. While his identity cannot be confirmed, it seems likely that he is a visiting member of the extended family, perhaps Anna's father, John Morgan, or another relation on her side of the family.

A View from the Château

Photographed from the south lawn looking down toward the Noye valley, this is the only view that omits the château (fig. 24). Not a pure landscape, it represents a site that has been carefully shaped by human intervention: a lawn or garden, rather than natural countryside. The artificiality of this scene is enhanced by the figures, their poses and attire clearly expressing their status as interlopers rather than native rural inhabitants. The twin sons are outfitted with hunting accoutrements, including rifles and pouches.

Two additional figures are introduced in this photograph, a pair of identically attired men in bowler hats standing before a seated Frédéric de Mercey (fig. 25). Their demeanor and proximity to de Mercey may provide clues to their identity; their reappearance in two other views (see figs. 26 and 27) suggests that they are connected to the household. Is it possible that they are Ludger Roisin and Timothée Piat, the two men who officially declared de Mercey's death at La Faloise in 1860? The village register identifies them as de Mercey's *gardes particuliers* and records their ages as forty-eight and thirty-nine, respectively. The men in this photograph appear to be the correct ages—forty-four and thirty-five in 1856—and are placed before de Mercey in a subservient position, as if reporting to him on an important matter. As *gardes particuliers,* their primary job was to oversee the conservation of the estate of La Faloise, including all aspects of forestry, gamekeeping, and fishing. If this identification is correct, then their presence might be interpreted as an expression of the family's authority over their vast country domain. The only potential inconsistency with this identification is the fashionable attire of the figures, which seems at odds with men of the working-class, but that may be explained by a desire to dress up for the very special occasion of being photographed. The mystery remains.

The Footbridge

A rustic footbridge across the Noye River provides the picturesque setting for a pair of group portraits taken from a single camera position. The garden façade of the château is visible at the top of the hill. In the foreground of the first view (fig. 26), the de Mercey family poses in a self-contained group. On the bridge, the two men in bowler hats are once again shown in close proximity, their reflections captured by the camera located on the near riverbank. The shadows cast by the trees in the distance and by Madame de Mercey's parasol suggest that the two views were photographed toward the middle of the day.

In the second view (fig. 27), the cast of characters and their poses have changed. The passage of time between the two views is indicated, in part, by the opening and closing of the château's windows. A white uniformed servant is seated on the road at the bottom of the hill, and the two men in bowler hats have reversed their positions. One looks down into the water, perhaps another clue to his function as *garde particulier*. While the son standing with a rifle remains in the identical pose and close to the same position as in the first view, the unusual placement of his father near the top of the hill (fig. 28), clearly visible only with the aid of magnification, demonstrates the great focal depth of Baldus's camera and

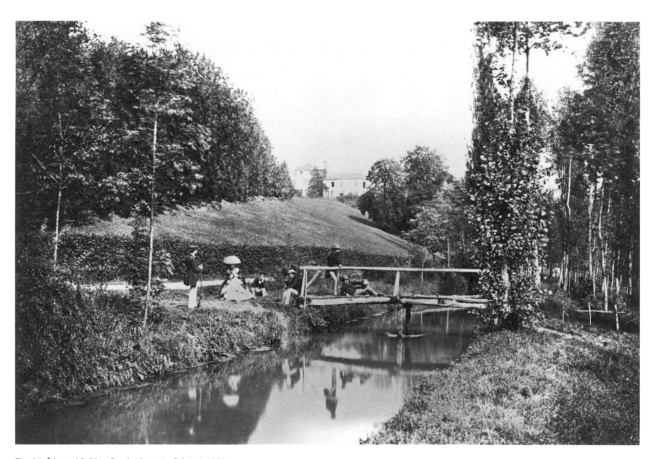

Fig. 26. Édouard Baldus, *Footbridge at La Faloise I,* 1856
Salted paper print from wet-collodion-on-glass negative, lightly albumenized, 11 ⅜ x 16 ⅝ in. (28.7 x 42.3 cm)
Musée d'Art Moderne et Contemporain de Strasbourg. Collections photographiques

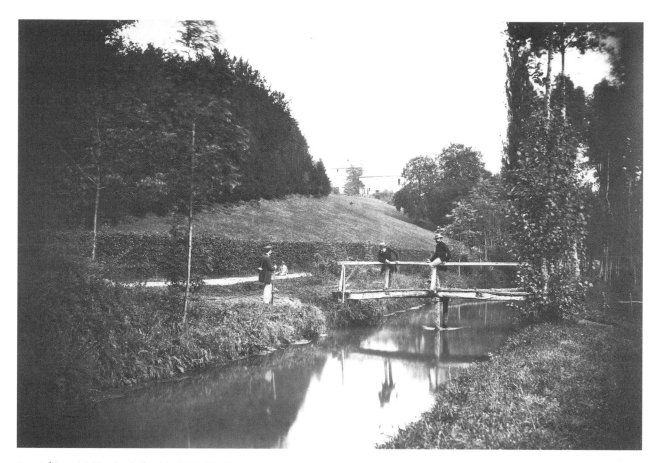

Fig. 27. Édouard Baldus, *Footbridge at La Faloise II*, 1856
Salted paper print from wet-collodion-on-glass negative, 11 ¼ x 16 ¼ in. (28.6 x 41.4 cm)
Philadelphia Museum of Art. Purchased with funds contributed by the American Museum of Photography

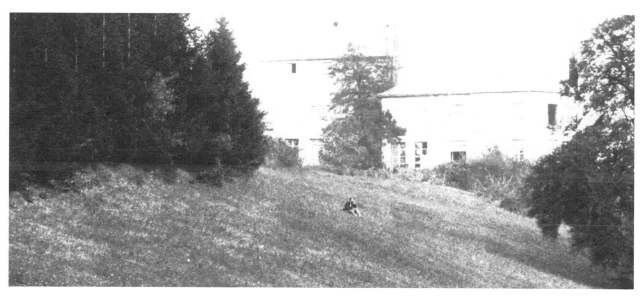

Fig. 28. Detail of fig. 27

sharpness of his negative. The movement of this figure to the top of the hill also suggests a whimsical subtext may underlie this series of images.

The Group on the Riverbank

For this photograph, Baldus moved his camera slightly up the riverbank (fig. 29). The family group and a servant appear on the far side of the river, with picnic baskets at their feet. Standing on the opposite riverbank with one arm leaning against a tree, the top-hatted older gentleman from the group portrait (see fig. 23) reappears in a jaunty pose. His physical separation from the family group emphasizes that he is a visitor to, rather than an occupant of, this domain. His identity remains a puzzle. The priest also reappears in this photograph, separated from the group, as he was in figure 22, almost hidden amid the foliage at the river's edge.

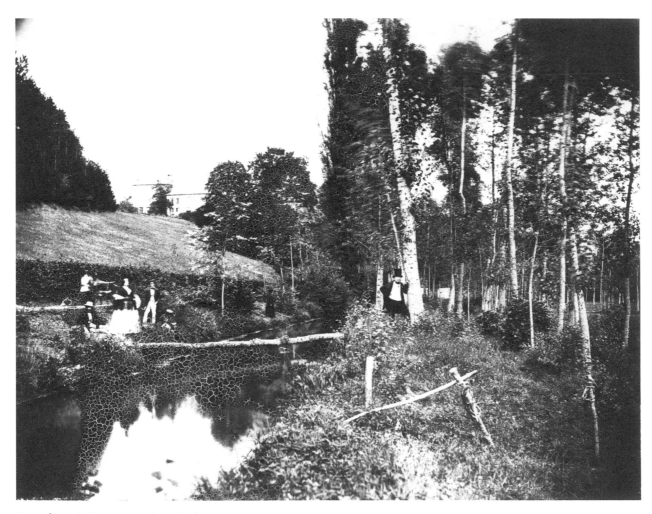

Fig. 29. Édouard Baldus, *Group on the Riverbank,* 1856
Salted paper print from wet-collodion-on-glass negative, 11 ¾ x 15 ⅜ in. (29.7 x 39.2 cm)
Bibliothèque nationale de France, Paris

Baldus's negative suffered some physical deterioration, causing a fine network of cracking or "crazing" in more than sixty percent of the image. The craquelure pattern is most noticeable in the lower left corner, in the area of the water, and extends diagonally throughout the image into the upper right corner. As the fine lines appear light rather than dark in the print, they may represent an early stage of damage, before the collodion coating in these areas had completely separated from the glass plate. The causes of this problem are unknown but could have been related to the composition of the glass itself and perhaps its exposure to high humidity, rather than a mishap in the preparation of the wet collodion.[58] Similar damage has been observed in some of Le Gray's glass-plate negatives recently found in the Bibliothèque Historique de la Ville de Paris.[59]

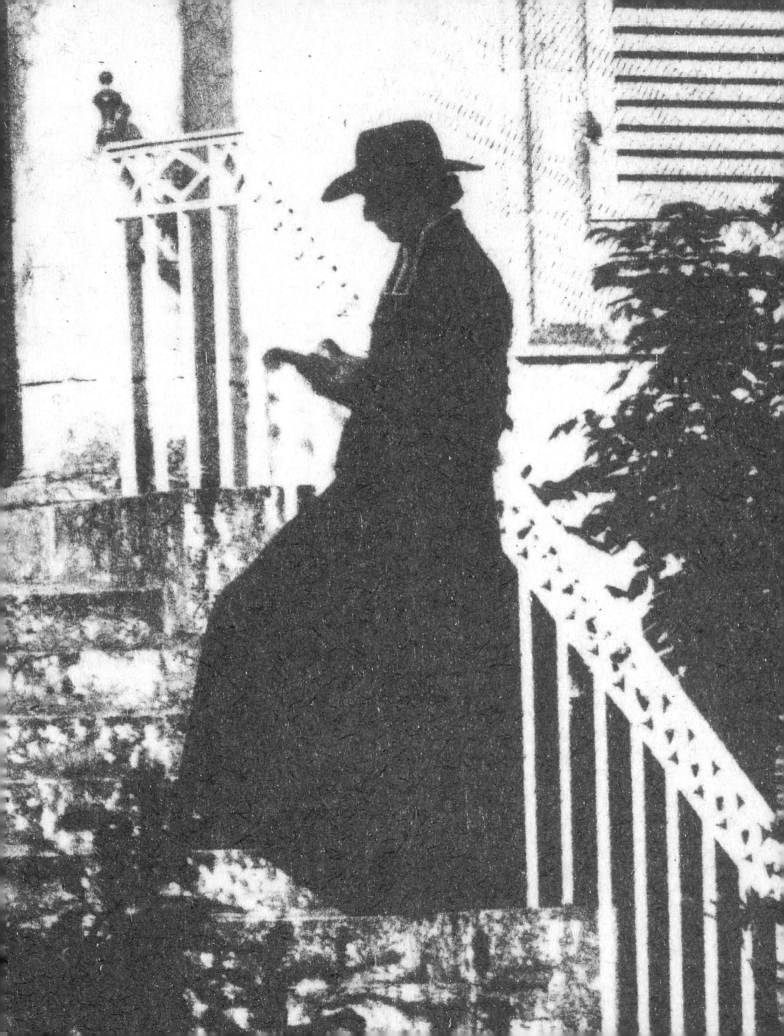

Shadows and Silhouettes

Portraits of living persons and groups of figures form one of the most attractive subjects of photography.... I have observed that family groups are especial favourites: and the same five or six individuals may be combined in so many varying attitudes, as to give much interest and a great air of reality to a series of such pictures.

—William Henry Fox Talbot (1844)

Talbot's unbridled enthusiasm for photographic group portraiture may be counterbalanced by A. A. E. Disdéri's statements in his *Essay on the Art of Photography* of 1862, in which the patent-holder of the carte-de-visite wrote of the challenges of this genre of portraiture. He complained:

The group portralt is often abused, and it is this genre that has attained the final limits of ugliness and implausibility. If it is already so difficult to properly pose a single person, to set him in the special conditions favorable to his likeness and appearance, then how many obstacles will be met when it is a question of composing a unique scene with individuals almost always of different physical type, age, and sex! Each has his own character and individuality that must give rise to a singular choice of pose, lighting, and expression. Through calculations of color and more or less extreme modifications of form that the resources of his art allow, the painter is still able to produce a certain unity of aspect out of all of these heterogeneous elements but the photographer, in the situation in which he is confronted by reality, will encounter, for the most part, impediments that the most ingenious and complex contrivances will not succeed in vanquishing.[60]

As a specialist in landscapes and architectural subjects, Baldus is not known to have had prior experience in group portraiture; the work that he carried out at La Faloise is unprecedented in his œuvre and was not repeated. As such, he did not have the luxury of relying on a highly refined stock of pictorial formulas in fulfilling this project. To some extent, the novelty of these photographs within his larger output may also be the result of a presumed creative collaboration between Baldus and his sitter, Frédéric de Mercey. In portraiture more than any other genre, the artist's directorial mode may be tempered by the will of his subject, so that the finished work reflects a meeting of minds rather than a solo performance. Given de Mercey's training as a painter and his position of authority as Director of Fine Arts, it is difficult to imagine that he would have assumed an entirely passive role in the conception and orchestration of these photographs.

One might go so far as to hypothesize that it was de Mercey's anglophilic taste, as much as the photographer's eye, that determined the special character of this series of images, setting them apart from the rest of Baldus's œuvre. There is little doubt that the formal structure of the photographs is derived from the distinctly British genre of the conversation piece, defined by scholars of English painting as "a portrait group of a family or friends in some degree of rapport seen in their home surroundings or engaged in some favorite occupation."[61] In the conversation piece, the setting is as important as the sitters, who are often portrayed on a relatively small scale within the larger frame. During the eighteenth century, an outdoor garden setting was considered best suited to the representation of aristocratic families.[62]

While countless comparisons may be made between Baldus's photographs of La Faloise and earlier conversation pieces, just one will suffice: Arthur Devis's portrait of *Robert and Elizabeth Gwillym and Their Family, of Atherton Hall, Herefordshire,* dated c. 1745–47 (fig. 30). Gwillym, the *pater familia,* stands at left with his own father and points to the opposite group, consisting of his wife and children. One of Gwillym's brothers poses with the group at right, while a servant approaches in the middle distance. The compositional formula of Devis's open-air portrait, with the family distributed in discrete groups in the garden of a grand house occupying a central position in the background, sets the stage for Baldus's views of de Mercey and his family at La Faloise. Both images convey a similar message: a portrait of a privileged lifestyle, one in which relationships are as important as likeness, and landscape represents property.

Because Baldus could readily produce multiple negatives in one sitting, he did not have to encapsulate his various agendas and objectives into a single image. Although painters of conversation pieces were usually commissioned to produce a single view incorporating architecture, grounds, and family, they were occasionally asked to paint multiple views documenting an estate's expansive gardens.[63] A close precedent in photography is a series of views of Bonaly Tower made in August 1847 by the Scottish photographers David Octavius Hill (1802–1870) and Robert Adamson (1821–48).[64] Located on the outskirts of Edinburgh, Bonaly was the home of Hill's friend, the distinguished jurist Henry, Lord Cockburn (1779–1854). Several of the photographs encompass the tower from some distance, with the diminutive figures of Lord Cockburn and his large entourage posing on the lawn. A pair of images shows Cockburn with his family, friends, and servants near the main entrance (fig. 31). Finally, the group is seen lounging on a hillside with Bonaly off in the distance in a seemingly informal— but rigidly posed—picnic scene.

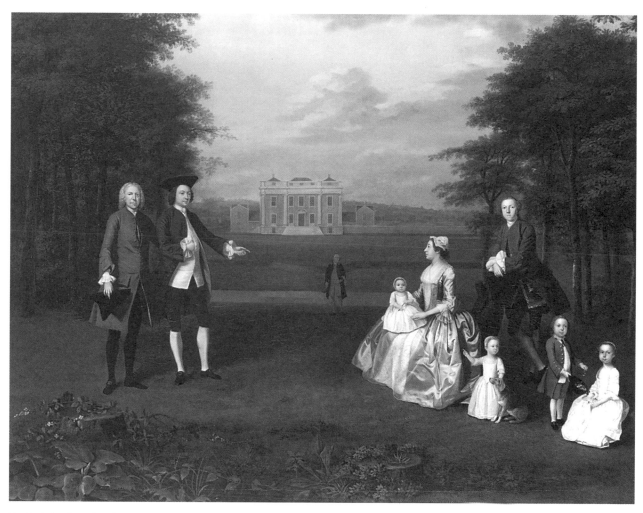

Fig. 30. Arthur Devis (British, 1712–1787), *Robert and Elizabeth Gwillym and Their Family, of Atherton Hall, Herefordshire*, c. 1745–47. Oil on canvas, 40 x 50 in. (101.5 x 127 cm) Yale Center for British Art, New Haven, Connecticut. Paul Mellon Collection

In his discussion of the photographic conversation pieces of William Henry Fox Talbot (1800–1877) and Nicolaas Henneman (1813–1898), showing family members, servants, and company posed on the grounds of Talbot's home, Lacock Abbey (fig. 32), Mike Weaver observed, "In early photography, the need to take pictures out-of-doors in order to obtain maximum sunlight rendered the landed gentry's activities more suitable for portrayal than those of the clerical and merchant classes."[65] The pictorial formulas of the conversation piece, as appropriated by Hill and Adamson and Talbot, are also reflected in English landscape photographs that were not conceived, in the first instance, as portraits. Roger Fenton (1819–1869) invokes this genre in a view of Dunkeld Cathedral (fig. 33). Here an anonymous group of three women poses on a park bench, while a young man reclines on the ground before them. Counterbalancing the figures, a gleaming sundial rises amid the foliage at left. This prominent motif, in concert with a pair of clocks marking 1:25 p.m. in the tower of the ruined cathedral, emphasizes the photographer's power to still a moment in time.

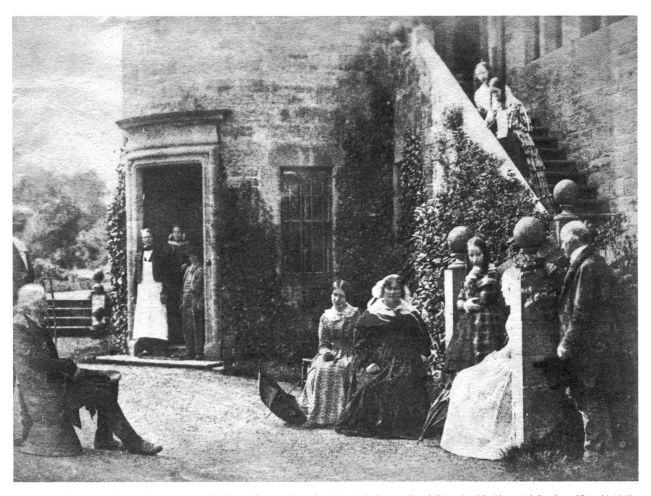

Fig. 31. David Octavius Hill (Scottish, 1802–1870) and Robert Adamson (Scottish, 1821–1848), *Group at Bonaly Tower (Lord Cockburn with Family and Friends),* 1847
Salted paper print from calotype negative, 6 x 8 in. (15.2 x 20.2 cm)
Collection of the Troob Family Foundation, on loan to the Sterling and Francine Clark Art Institute, Williamstown, Massachusetts

In Baldus's vast œuvre, the photographs that are the closest in conception to his work at the Château de La Faloise are to be found, perhaps unexpectedly, among the products of one of his major government commissions: the photographic documentation of Lefuel's construction of the new Louvre, and attendant renovations of the old Louvre, Tuileries Palace, and gardens. In 1855 Baldus began the process of making several thousand negatives showing every step in the progress on one of Napoléon III's most ambitious projects.[66] He worked in a variety of formats and scales, focusing at times on details of sculptural ornamentation, at others stepping back to take in the monumental façades.

One of the most interesting groups of images is a series of small-format views of the Tuileries Gardens, recording the placement of stone benches, ornamental vases, and sculptures in the new private garden—the *jardin réservé*—for the empress and her infant son, the prince imperial.[67] These views are populated with an assortment of figures, both to impart a sense of scale as well as give life to what would have otherwise been a series of banal documentary images. In one photograph, meant to document a marble bench with rococo ornamentation originating from the Parc de Marly,[68] Baldus employs three

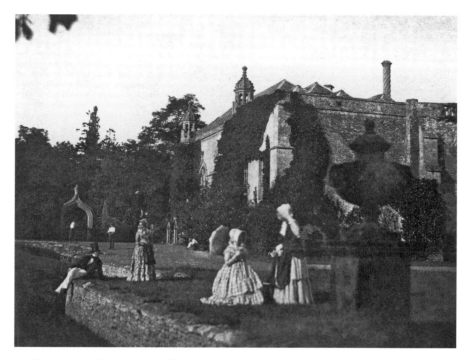

Fig. 32. Attributed to Calvert Jones (British, 1802–1877) and William Henry Fox Talbot (British, 1800–1877)
Group in Garden at Lacock Abbey, c. 1843
Salted paper print from calotype negative
Location unknown

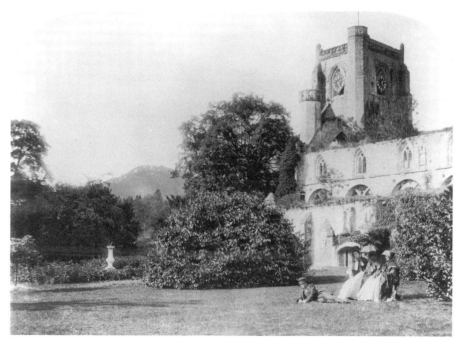

Fig. 33. Roger Fenton (British, 1819–1869), *Group at Dunkeld Cathedral,* 1856
Albumen print from wet-collodion-on-glass negative, 12 ¾ x 16 ¾ in. (32.4 x 42.5 cm)
H. H. Richardson Collection, Frances Loeb Library, Harvard University Graduate School of Design,
Cambridge, Massachusetts

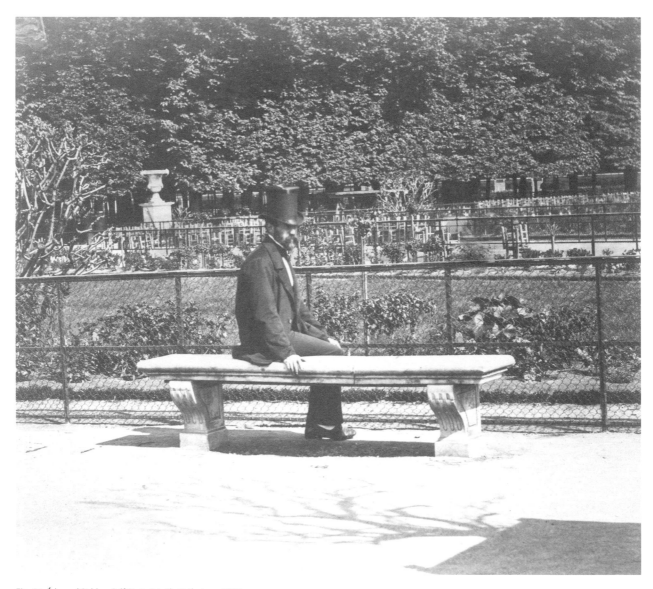

Fig. 34. Édouard Baldus, *Self-Portrait in the Tuileries*, c. 1856
Salted paper print from wet-collodion-on-glass negative, 6 ¾ x 7 ½ in. (17 x 19.1 cm)
Collection of the Troob Family Foundation, on loan to the Sterling and Francine Clark Art Institute, Williamstown, Massachusetts

figures (fig. 35). Two men sit on the bench, while a third man in a white smock stands motionless between them, facing the camera in a pose that coincidentally recalls Jean-Antoine Watteau's *Pierrot*. A black top hat is placed in the shade beneath the bench; perhaps it belongs to the photographer, who poses on yet another stone bench in a rare, impromptu self-portrait as a *flâneur* (fig. 34).[69] One is reminded in these photographs of the commentary in the *Guide des promenades* of 1855, which called the Tuileries the "promenade of Paris" and reported that it "no longer attracts one particular type, one group of the population. It is a hodgepodge of childhood and maturity, merchant and artist, officer and civil servant."[70]

Fig. 35. Édouard Baldus, *Stone Bench with Three Men in the Tuileries*, c. 1856
Salted paper print from wet-collodion-on-glass negative, 7 x 7 ½ in. (17.8 x 19 cm)
Collection of the Troob Family Foundation, on loan to the Sterling and Francine Clark Art Institute, Williamstown, Massachusetts

It is with these remarkable images of the Tuileries Garden that I wish to return to a premise with which this essay began, a longing on the part of art historians to trace formal and iconographic connections between Baldus's photographs of the Château de La Faloise and plein-air portraiture in early Impressionist painting. It is also tempting to read Baldus's self-portrait in the Tuileries as a "proto-Impressionist" photograph, a representation of urban leisure in a modern pleasure garden of the type painted by Manet, Monet, and Renoir. But while Baldus's syntax is indeed similar to that of the Impressionists, to interpret his image in this way is to misconstrue the photographer's intentions and the circumstances surrounding

Fig. 36. Detail of fig. 21

its production. Although Baldus exhibits the trappings of a smart Parisian at leisure, he is actually a man at work, a photographer in the employment of the emperor documenting a renovation project. Isolated from its proper discursive space, the photograph appears as a generic emblem of modern life in the Second Empire, like the portraits of Frédéric de Mercey and his family at La Faloise read as representations of a "Group in a Park" (fig. 36).

I have characterized Baldus's photographs of the Château de La Faloise as grounded in French anglomania and the genre of the conversation piece, but is there any lasting value in situating them in a continuum extending forward to early Impressionist painting? Perhaps the most compelling and direct comparison can be made between certain of Baldus's photographs and the first version of Frédéric Bazille's *Terrace at Méric,* rejected from the Salon of 1867 (fig. 37), which shows the artist's family group in the garden of their country residence in Montpellier. The primary figure group is posed as if in casual conversation, much like the de Mercey family before the garden façade of their château. In *The Terrace at Méric,* the family's placement in relation both to the architecture and to the viewer reflects the painter's desire to portray the château as an extension of their wealth and social status. One Bazille scholar has suggested that the painting was not intended as a group portrait but rather as a "diary of bourgeois leisure,"[71] the same label that has been applied to Baldus's views of La Faloise. Like Bazille's painting, Baldus's photographs reflect a distinctive lifestyle in a way that recalls contemporary popular

imagery of leisure activities. And from the point of view of the 1860s, Baldus appears progressive in achieving a successful balance between the human figure and the open-air landscape.

Beyond such superficial similarities, what did Baldus have in common with the vanguard painters of the 1860s and 1870s? Like the Impressionists, Baldus and many other photographers of his generation began their careers as painters who tried—and frequently failed—to succeed within the Salon system. Through the auspices of the Société française de photographie, they organized a series of eleven exhibitions in Paris from 1855 to 1877 in which they showed their photographs together outside of the Salon, striving for recognition and attention from art critics. Coincidentally, their exhibition space in 1857, the year that Baldus showed one view of the Château de La Faloise, was to be the site of the first exhibition of the Société anonyme des artistes peintres, sculpteurs, graveurs—the Impressionists—in 1874.

Fig. 37. Frédéric Bazille (French, 1841–1870), *The Terrace at Méric,* 1867
Oil on canvas, 38 ¼ x 50 ⅜ in. (97 x 128 cm)
Association des Amis du Petit Palais, Geneva

Reviewing the 1857 exhibition, Théophile Gautier was among the first to apply the familiar polemic of draftsman versus colorist to contemporary photography, and in so doing suggests a way in which Baldus's photographs may be reconsidered in the context of vanguard painting:

> **Individuality reigns among the French; each acts according to his own particular idea: the same diversity of genre is found in the Photographic Exhibition as at the Salon. One thing that seems strange, but true, is that there are among the French photographers the *dessinateurs* and the *coloristes*: the former define their contours, neatly cutting out their silhouettes, admitting only white or gray tints; the latter darken the edges of objects, concentrating their light, thickening their shadows, reanimating their tones, giving their blacks the appearance of velvet from the knowledge of elaborating the work of the sun like an old etching by Rembrandt printed on yellow paper.[72]**

The critical consensus was that among photographers, the so-called *dessinateurs,* primarily motivated by clear and literal reproduction, were less successful as artists, while the *coloristes* benefited from their willingness to sacrifice detail.[73] In his seminal article "Théorie du portrait" of 1851, Francis Wey established himself as one of the most outspoken advocates of

applying the so-called Theory of Sacrifices to the medium of photography.[74] Henri Zerner has recently discussed Le Gray, Nègre, and Le Secq in the context of the colorist avant-garde of the mid-nineteenth century, and Baldus may also be placed among their ranks on the basis of his work at the Château de La Faloise and elsewhere.[75]

On the eve of the opening of the Exposition Universelle in 1855, Baldus's patron Frédéric de Mercey entered into this spirited discourse when he wrote, "Literal imitation is one of the elements of art, but it is not the principal element. Thus it is troublesome that the majority of the contemporary school, whatever their inclinations, have given this element a considerable importance, so that pure and simple imitation seems to have become for them the basis for art." In a footnote to this statement, he added:

> **By this reckoning, the daguerreotype will be the foremost of all artists, and the painter will have to break his crayons and pencils. This new rival, as redoubtable as it appears, should not alarm true artists. Never will the mechanical process approach the human hand guided by man's genius. We neither disavow the incontestable utility nor the unequaled exactitude of the daguerreotype. Thanks to its precision and rapidity, this process appears to us preferable than any other for recording its souvenirs. It is indispensable to every traveler who wants to reproduce the special physiognomy of a region, its monuments and the details of its architecture. Applied to the portrait or the landscape properly speaking, its results are not completely satisfying. It is a tracing of nature, and what tracing, no matter how exact, has ever approached a copy made with intelligence by a talented artist? What cast has ever equaled the part of a statue by a genius taken from a living model before his eyes? It isn't everything to reproduce nature exactly, it is necessary to give it life.[76]**

At the Château de La Faloise, Baldus demonstrated his allegiance to photographic colorism as championed by Wey, as if in response to de Mercey's position and in a calculated effort to persuade him of the artistic merits of photography. For instance, in his portrayal of Madame de Mercey in figure 23, Baldus allowed deep shadows to fashion an aloof and mysterious image, one that transcends the literal. Protected from the sun by a parasol, she recedes into the darkness, her delicate profile only faintly legible (fig. 38). Whether the obscuring of the sitter's facial features can be attributed to coquettishness or timidity, we can only assume that this effect was deliberate on the part of the photographer. In fact, Baldus's image is squarely at odds with the basic tenets of portraiture as spelled out by Disdéri. While he advised the photographer to carefully control light and shadow to ensure a proportional and therefore beautiful representation of the sitter's features, Disdéri did not admit the practice of plunging his subject in deep shadow, obliterating all traces of physiognomy and expression.[77]

In producing figure 22, the most profoundly dark and "colorist" image in the series, Baldus undoubtedly bore in mind his patron's disapproval of the daguerreotype's precision, at once teeming with detail but lacking in life. Like Madame de Mercey, the silhouetted figure of the village priest on the staircase contributes to an air of mystery (fig. 39). His isolation

Fig. 38. Detail of fig. 23

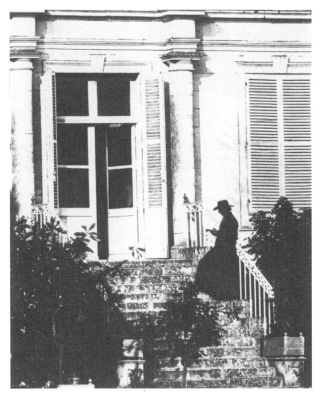

Fig. 39. Detail of fig. 22

from the primary group, and his striking pose against the bright white façade of the château, makes him the focal point of the composition, yet his likeness is withheld. Another solitary figure of a man, barely legible on a bench amidst the dark shadows, adds to the sinister atmosphere: who is this unidentifiable figure, and why is he isolated in this way? This photograph is no facile representation of people and architecture; it is a dexterous study of shadows and silhouettes, the theory of sacrifices put into practice.

As a photographer, Baldus showed time and again that he was unafraid of the dark, though he sometimes met with criticism for the extremes of chiaroscuro they perceived in his prints. In his review of the 1855 Exposition Universelle, Paul Périer complained that certain of Baldus's "proofs are pushed too far in printing, or removed too early from the fixing bath, whence result shadows of an intensity completely outside the range of normal tones and which offer nothing more than black spots, dull and lifeless, impenetrable to both eye and mind, and which allow nothing to be seen in their darkness."[78]

There is no question that impenetrable shadows enhance the enigmatic and evocative qualities of Baldus's photographs. The château's windows, open in some views and shuttered in others, punctuate the images in the most tantalizing manner. In his prose-poem "Les Fênetres," Charles Baudelaire famously wrote, "What one can see out in the sunlight is always less interesting than what goes on behind a windowpane. In that black or luminous square, life lives, life dreams, life suffers."[79] The gaze of the voyeur—the viewer from outside looking in—is forever inhibited. It is a classic paradox of nineteenth-century photography that the limitations of Baldus's lens, and the occasional absence of visual information in his photographs, actually enrich our viewing experience.

Whether photographing the construction of the new Louvre, the railroad stations of the *Chemin de fer du nord,* or the floodwaters in Avignon, Baldus adhered to a clear agenda that informed the technical and compositional decisions he faced in the field. At the Château de La Faloise, he was given a unique opportunity to extend his vision into what was for him an unfamiliar genre, and the results reveal a little-known side to one of the most talented photographers of the Second Empire. In a passionate response to the work of Baldus and his contemporaries, Gautier declared, "Every famous photographer has his stamp, and his prints do not need his signature in order to be distinguished from the others." He went on to enumerate the myriad variables that combine to shape the photographic image:

This is a result of the lenses, the chemical agents, the albumen or collodion, the washing, the waxed paper or the glass plate, the weather on a particular day, the number of minutes or seconds of the exposure, the color, the subject, the degree of immobility of the model; a little, undoubtedly, derives from all of these circumstances, but principally from the artist's taste, his manner of looking and comprehending things, from choosing, arranging, laying them out, and above all—why shouldn't we express it?—from a certain fluid transmission, that science is not in a position to determine today, but which nonetheless exists. Do you think that these plates, adequately prepared for light sensitivity, would be unmodified by human intervention? Here we touch on a delicate question: can the spirit affect matter? Magnetism seems to respond: *yes.*[80]

Taken as a whole, Baldus's photographs of the de Mercey family at their country house make a powerful artistic statement, the syntax of which he derived from the conventions of painting but the language of which was clearly his own. Although he exhibited a single print in 1857, the primary audience for his photographs was not the general public but the sitters portrayed therein. Their chance survival must not be taken for granted, given the disappearance of some of his most celebrated works.[81] Unfortunately for Baldus, Frédéric de Mercey's health and his power within the arts administration both declined following the Exposition Universelle of 1855, so it is unlikely that the photographs could have made any substantive impact in the ongoing campaign to elevate the status of this new medium. How they were received in their time remains one of a number of frustrating open questions. Even in the wake of the intense archival and art historical scrutiny to which they have been subjected in this study, Baldus's photographs of the Château de La Faloise retain their distance and remain his most evocative and elusive achievements.

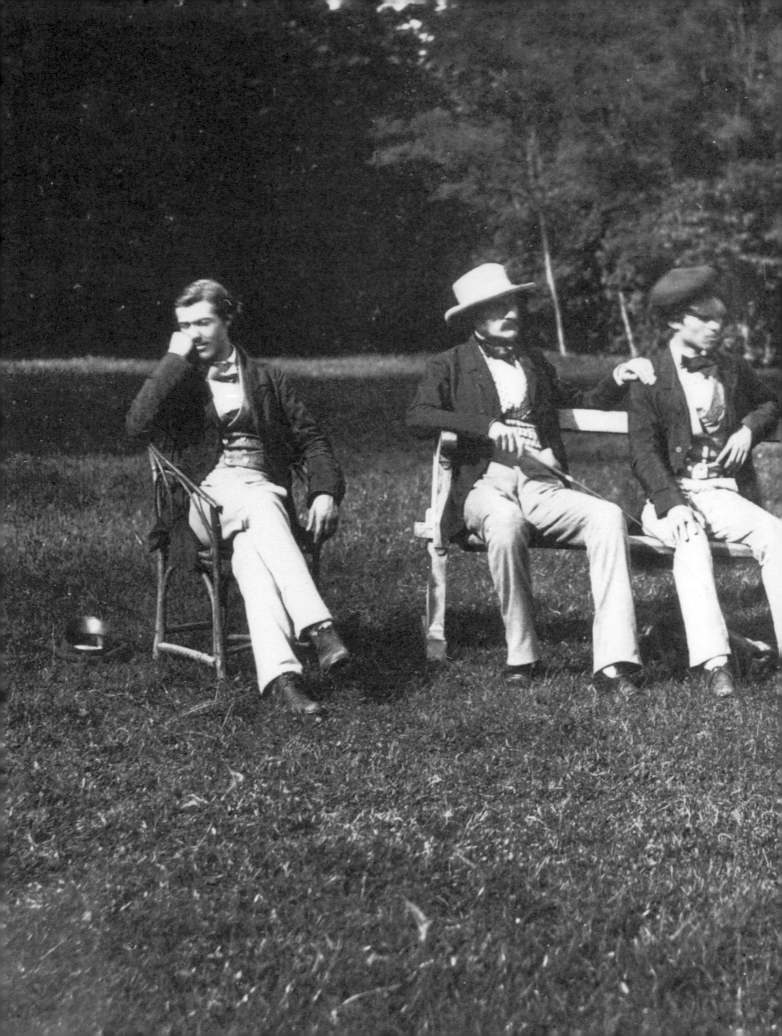

Appendix

"La photographie à la campagne"
by Ernest Lacan

Reprinted from *La Lumière*, 18 July 1857

"Photography in the Countryside"
by Ernest Lacan

Reprinted from *La Lumière*, 18 July 1857

Or, ce matin-là (c'était l'autre semaine), une animation extraordinaire régnait au château de F... D'aimables femmes, éveillées avant l'heure habituelle, parcouraient, sous l'empire d'une préoccupation évidente, les frais salons, les serres embaumées, les tranquilles allées du jardin, quelques-unes même s'enfonçaient sous les ombrages profonds du parc. Plusiers reparaissaient, après une courte absence, avec une nouvelle toilette et venaient s'offrir aux regards de leurs compagnes en leur demandant: Serai-je mieux ainsi?

Puis, quand le roulement d'une voiture se faisait entendre sur le pavé sonore de la rue, on écoutait, les jeunes filles couraient aux fenêtres, et quand le bruit séloignait, on murmurait avec désappointement: Ce n'est pas encore lui!

Quel pouvait être l'heureux mortel si impatiemment attendu?

Enfin la grille s'ouvrit; l'immense voiture affectée au service des visiteurs entra bruyamment dans la cour d'honneur.

—Le voici! le voici! cria-t-on de toutes parts.

Et notre ami Millet fit son entrée triomphale, accompagnée de deux préparateurs et suivi de tout son bagage de photographie.

Beaucoup de personnes croient encore, à l'heure d'intelligence et de savoir où nous vivons, que pour faire une épreuve photographique il suffit tout uniment de se placer avec une chambre noire devant le modèle, l'objet ou le site à reproduire, le soleil et la machine se chargeant

Now, one morning (it was the other week), unusual excitement prevailed at the château de F... A group of cheerful women, rising before their usual hour, and clearly under some obsessive spell, ran all around the cool rooms, the fragrant conservatories, the tranquil paths of the garden, some even plunging into the deep shade of the park. Several reappeared after a brief absence wearing new dresses, which they showed their companions and asked: are these more attractive?

Then, hearing the rumbling of a carriage on the paving stones, the young women ran to the windows, and when the noise abated, they murmured with disappointment: he is not here yet!

What lucky mortal could be awaited so impatiently?

Finally, the gate opened; the enormous carriage employed by the visitors noisily entered the main courtyard.

—"He is here! He is here!" they all exclaimed.

And our friend Millet[82] made his triumphal entrance, accompanied by two assistants and followed by all of his photographic baggage.

Many people still believe, in the age of intelligence and knowledge in which we live, that in order to make a photographic print it is simply necessary to place oneself with a camera obscura before the model, the object, or the scenery to be reproduced, and the sun and the apparatus will take care of the rest. There are others, even among the initiated, who, having obtained satisfac-

du reste. Il en est d'au[t]res, même parmi les initiés, qui, ayant obtenu des résultats assez satisfaisants dans un atelier bien organisé, s'imaginent opérer mieux et plus facilement encore en plein air.

Ces amateurs-là ne songent pas que dans une cour entourée de murs, sur lesquels les rayons du soleil viennent frapper; dans un jardin, où tout prend une teinte verte sous les reflets du feuillage, la lumière ne se comporte pas du tout de la même façon que dans un atelier vitré, muni d'écrans mobiles et de *fonds* bleus ou gris.

Ceux dont nous parlons eussent été bien surpris de voir Millet chargé de son pied articulé, surmonté de deux appareils stéréoscopiques, parcourir les cours, les allées, les vestibules avec des gestes de désappointment. Il cherchait sa place et ses lumières. La recherche fut longue et minutieuse, mais le succès démontra bientôt avec quelle habileté l'artiste avait choisi. Nous devons le dire, ce fut dans la basse cour qu'il s'installa! Qu'important les moyens quand le résultat est complet?

Quand tout fut bien installé, Millet commença par un groupe de deux dames. Le ciel était voilé, on posa six secondes: l'épreuve était brûlée. A quatre secondes on obtint deux plaques magnifiques. A partir de ce moment jusqu'à six heures du soir, Millet ne avaient-ils le temps de polir et *d'ioder* les plaques et de développer les images. Pas une seule fois on n'eut à recommencer, tout était réussi d'emblée. C'était merveilleux.

En arrivant, l'habile photographe comptait avoir à faire cinq portraits; mais on fut si satisfait des premiers qu'il montra, il paraissait en si bonne veine, et d'ailleurs on trouvait tant de plaisir à cette nouveauté champêtre, qu'on voulut faire participer quelques privilégiés à cette petite fête artistique. On fit prévenir une ou deux personnes amies, qui se gardèrent bien de refuser l'invitation; puis les nouveaux arrivés se firent à leur tour propagateurs de la nouvelle. Des visiteurs venus par hasard de Paris voulurent à leur tour profiter de l'occasion; si bien qu'il arriva un moment où la basse-cour, changée en

tory results in a well-organized studio, imagine themselves working better and more easily outdoors.

The former connoisseurs think that in a courtyard surrounded by walls, upon which rays of sunlight happen to strike, or in a garden, where everything takes on a green tint under the reflection of foliage, light would act in the same manner as in a glazed studio, furnished with moving screens and blue or gray *backdrops*.

Those of whom we speak would be shocked to see Millet loaded with his tripod, surmounted by two stereoscopic cameras, traversing the courtyards, paths, and vestibules with gestures of disappointment. He was looking for his position and his light. The search was long and meticulous, but his success soon demonstrated the degree of competency with which the artist had made his choice. We must report, it was in the poultry yard that he set himself up! But who cares about the means when the results are complete?

When everything was properly installed, Millet started with a group of two women. The sky was cloudy, the pose was six seconds: the impression was burned. In four seconds he obtained two magnificent photographic plates. From that moment until six o'clock in the evening, Millet did not have time to polish or iodize the plates and develop the images. Not once did he have to start over, as everything succeeded in one attempt. It was marvelous.

Upon his arrival, the skillful photographer expected to make five portraits; but his sitters were so pleased with the first results, he seemed to have such good fortune, and moreover, they found so much pleasure in this rural novelty, that they wanted to invite certain privileged people to participate in this little artistic fête. They informed one or two friends, who were eager to accept the invitation; then, new ones arrived and in turn spread the news. Visitors arriving by chance from Paris wanted, in turn, to profit from the occasion; so that the moment arrived that the poultry yard, changed into a salon, was too small to contain the crush of models, and

salon, fut trop petite pour contenir la foule des modèles, et que le nombre des plaques diminuant, il fallut renoncer à satisfaire toutes les demandes. C'était vraiment dommage!

Millet avait apporté quarante-huit plaques; il remporta vingt-quatre portraits stéréoscopiques. Pas une plaque ne fut perdue, et s'il en eût apporté soixante, toutes auraient servi. J'ajouterai que ces portraits peuvent être considérés comme les meilleurs qu'il ait produits.

Nous avons été témoin oculaire de tout ce que nous venons de raconter, et nous nous faisons un plaisir de rendre témoignage à l'intelligent et laborieux artiste, de l'habileté dont il a fait preuve en cette circonstance, et de l'impression favorable qu'il a laissée dans l'esprit de tous ceux qui l'ont vu à l'oeuvre.

Par une singulière coïncidenne, le lendemain de ce jour nous assistions à une séance du même genre; cette fois c'était M. Ferrier qui opérait. Les difficultés étaient peut-être plus grandes encore, car il s'agissait de reproduire un groupe de quinze personnes, sous un dais de feuillage et à contre-jour. En dépit de ces difficultés et comme nous nous y étions attendu, connaissant l'expérience et le talent de M. Ferrier, le résultat a été des plus satisfaisants.

Nous avons pu juger une fois de plus dans cette circonstance, du service rendu par notre regrettable ami Taupenot à la photographie.

En effet, les glaces dont M. Ferrier se servait avaient été préparées au collodion albuminé, et dataient d'un mois environ.

La durée de l'exposition n'a pas dépassé 10 secondes, et malgré les oppositions résultant de vêtements de couleurs diverses, depuis le blanc jusqu'au noir, l'ensemble des épreuves présente une harmonie remarquable, chaque ton ayant pris sa valeur. L'artiste n'avait eu à emporter, en outre de ses deux objectifs et des châssis contenant les glaces préparées d'avance, qu'un petit godet pour la solution d'acide gallique et une lampe à

when the plates ran out, the photographer had to give up satisfying the demand. It was really a shame!

Millet had brought forty-eight plates; he took back twenty-four stereoscopic portraits. Not one plate was lost, and if he had brought sixty, all would have been served. I add that the portraits may be the best he ever made.

We have been eyewitness to all that we have recounted, and we have taken pleasure in testifying concerning the intelligent and hardworking artist, the skill that he demonstrated on this occasion, and the favorable impression that he made on all those who saw him work.

By a singular coincidence, the next day we assisted in a sitting of the same type; this time, it was Mr. Ferrier[83] who operated the camera. The difficulties were perhaps even greater because it was a matter of reproducing a group of fifteen people, backlit and under a canopy of foliage. In spite of these difficulties, and as expected, knowing the experience and talent of Mr. Ferrier, the result was most satisfying.

We were again able to judge in this situation the service rendered by our poor friend Taupenot[84] to the field of photography.

Indeed, the glass plates that Mr. Ferrier employed had been prepared with albumenized collodion, aged about a month.

The length of the exposure did not exceed ten seconds, and despite the oppositions resulting from the multicolored clothing, from the white against the black, on the whole the prints exhibit a remarkable harmony, every tone having captured its value. The artist had nothing to transport, in addition to his two lenses and the printing frame containing the negatives prepared in advance, other than a small cup for the solution of gallic acid and a spirit lamp. Moreover, he could have waited to develop his images until his return, if he had not committed to immediately showing the result. Indeed, there is no other process that displays such simplicity and causes less

esprit de vin. Encore eût-il pu ne développer ses images qu'au retour, s'il n'avait tenu à montrer immédiatement le résultat. Certes, il n'est pas de procédé qui présente autant de simplicité et cause moins d'embarras. Il faut dire aussi en toute justice que M. Ferrier le pratique avec une assurance et une habileté peu communes.

On a trouvé déjà bien des choses pour se distraire pendant les jours de calme, parfois un peu monotones, que l'on passe à la campagne, mais on n'avait pas encore songé à la photographie. Pourtant, si nous en jugeons par ce qui s'est passé sous nos yeux dans les deux occasions que nous venons de citer, elle est de nature à occuper pendant de longues heures et de la façon la plus agréable, toute une société, fût-elle composée exclusivement de dames.

Nous la signalons donc aux propriétaires de châteaux, villas ou maisons de campagne, qui tiennent à honneur de recevoir le mieux possible leurs invités.

Nous désirons vivement que cette nouvelle mode soit admise; la vie du château y gagnera une charmante distraction, la photographie d'agréables oeuvres, et les photographes n'y perdront pas, surtout s'ils sont reçus comme au château de F....

encumbrance. I must add in all fairness that Mr. Ferrier carried it out with an uncommon assurance and skill.

People have previously found many activities with which to distract themselves during the days of tranquility, and at times, monotony, which are spent in the country, but they have not yet considered photography. However, to judge by what has passed before our eyes on the two occasions that we have just cited, it is likely to occupy, during the long hours and in the most agreeable manner, all of a social circle, even if it were composed exclusively of ladies.

We thus point this out to all owners of châteaux, villas, or country cottages, who have the honor to receive their guests in the best possible manner.

We eagerly desire that this new fashion will catch on; life in the château will gain a charming distraction, photography will gain pleasing works, and the photographers will not fall into disuse, especially if they are received as at the château de F....

Notes

The epigraphs that appear throughout this essay are from the following sources: Susan Sontag, "Melancholy Objects," in *On Photography* (New York: Farrar, Straus and Giroux, 1977), 71; Louis-Jacques-Mandé Daguerre, "Daguerreotype" (Paris: Pollet, Soupe et Guillois, 1838–39), reprinted in Quentin Bajac and Dominique Planchon-de Font-Réaulx, *Le daguerréotype français: Un objet photographique,* exh. cat. (Paris: Réunion des musées nationaux; Musée d'Orsay, 2003), 384; Beaumont Newhall, *The History of Photography: From 1839 to the Present,* rev. ed. (New York: Museum of Modern Art, 1982), 94; John Berger, "Understanding a Photograph," 1968, in *The Look of Things* (New York: Viking, 1972), reprinted in *Selected Essays / John Berger,* ed. Geoff Dyer (New York: Pantheon, 2001), 217; Ernest Lacan, "La photographie à la campagne," *La Lumière,* 18 July 1857, 113; William Henry Fox Talbot, from description accompanying plate 14, "The Ladder," in *The Pencil of Nature* (London: Longman, Brown, Green, and Longmans, 1844), unpaginated. Unless otherwise indicated, all translations from the original French are by the author.

1. On Sirot, see Eliette Bation-Cabaud, "Georges Sirot, 1898–1977, une collection de photographies anciennes," *Photogénies,* no. 3 (Oct. 1983), unpaginated; and Anne de Mondenard, "La ronde des collectionneurs," in Roger Thérond, *Une passion française, photographies de la collection de Roger Thérond,* exh. cat. (Paris: Filipacchi: Maison européenne de la photographie, 1999), 17–43.

2. Quoted from a conversation with Maria Morris Hambourg in *The Waking Dream: Photography's First Century,* exh. cat. (New York: Metropolitan Museum of Art, 1993), xvi.

3. *Présence de la photographie* (Paris: Musée Kodak-Pathé, 1969), 36.

4. According to Gérard Lévy, who sold the photograph to the Musée Kodak-Pathé, the inscription was made at his request and in his presence circa 1967.

5. *The Second Empire, 1852–1870: Art in France Under Napoleon III,* exh. cat. (Philadelphia: Philadelphia Museum of Art, 1978), 403.

6. The exhibition originated at the Worcester Art Museum and was also shown at the National Gallery of Art, Washington, and the Ackland Art Museum, Chapel Hill.

7. *Visions of City and Country: Prints and Photographs of Nineteenth-Century France,* exh. cat. (Worcester, Mass.: Worcester Art Museum, 1982), 239.

8. *A Day in the Country: Impressionism and the French Landscape,* exh. cat. (Los Angeles: Los Angeles County Museum of Art, 1984), 358.

9. Françoise Heilbrun, *Les paysages des impressionnistes* (Paris: Éditions Hazan, 1986), 35.

10. Malcolm Daniel, *The Photographs of Édouard Baldus,* exh. cat. (New York: Metropolitan Museum of Art, 1994), 71 73. In footnote 177 on p. 267, Daniel lists the photographs then known to him as in the Gilman Paper Company Collection (now at the Metropolitan Museum of Art), Canadian Centre for Architecture, Musée d'Orsay, and two in a private collection, Paris.

11. Ibid., 72.

12. Ibid., 73.

13. *Édouard Baldus: Landscape and Leisure in Early French Photography,* 4 Oct.–28 Dec. 2003. For more information on this exhibition, including a list of works that appeared in the show, visit *http://www.clarkart.edu/exhibitions/baldus/*.

14. Roland Barthes, *Camera Lucida: Reflections on Photography,* trans. Richard Howard (New York: Hill and Wang, 1981), 106.

15. Marshal G. Penfield, "Summary of the Section's History Under the United States Army," History of the American Field Service in France website, "Friends of France,"

1914–17, Told by Its Members, *http://www.lib.byu.edu /~rdh/ wwi/memoir/AFShist/AFS2d.htm* (accessed Jan. 2004).

16. Philippe Seydoux, *Gentilhommières en Picardie, Amiénois et Santerre* (Paris: La Morande, 2002), 103.

17. In addition to Seydoux's book (ibid.), see Jules Mollet, *Montdidier: Géographie historique et statistique de l'arrondissement,* Monographies des villes et villages de France, no. 4 (1889; repr., Paris: Res Universis, 1992), 56–57; Yvan Christ, *Dictionnaire des châteaux de France* (Paris: Berger-Levrault, 1978), 137.

18. Victor de Beauvillé, *Recueil de documents inédits concernant la Picardie,* vol. 2 (Paris: Impériale, 1867) and vol. 4 (Paris: Impériale, 1881), 412–13, n. 5; quoted in Seydoux, *Gentilhommières en Picardie,* 103.

19. Société des antiquaires de Picardie, Fondation Edmond Soyez, *La Picardie historique et monumentale: tome 2, arrondissement de Montdidier* (Amiens: Imprimerie Yvert et Tellier; Paris: Libraire A. Picard, 1901–2), 125.

20. The life dates of Elisabeth-Geneviève and François-Alexandre Desprez are unknown.

21. M. Hoefer, *Nouvelle biographie générale depuis les temps les plus reculés jusqu'à 1850–60* (1852–66; repr., Copenhagen: Rosenkilde et Bagger, 1963–69), 35:14.

22. Inventaire après décès de Frédéric Bourgeois de Mercey, MC/ET/11/1113, Archives Nationales de France, Paris.

23. Société des antiquaires de Picardie, *La Picardie historique,* 123.

24. Hittorf and de Mercey were both admitted into the Académie des Beaux-Arts in 1853.

25. *L'Artiste* 10 (15 Sept. 1860): 142.

26. Charles Blanc, "M. Frédéric de Mercey," *Gazette des Beaux-Arts* 7 (15 Sept. 1860): 375.

27. B. de Boisdenier, "M. F. de Mercey," *Le Siècle,* 8 Jan. 1861.

28. A large portfolio of Frédéric de Mercey's drawings surfaced in the autumn of 1968 in *catalogue périodique* no. 48 of Paul Prouté, Paris, pp. 14–18, nos. 203–74; three of his paintings appeared in Prouté's April 1969

catalogue, nos. 65–67. More recently, an oil on canvas (*Vue du port de bastia,* 1839) appeared at Christie's, Monaco (14 June 1996, lot 55), and an oil on canvas representing a wooded landscape, dated 1849, sold at Phillips, London (3 Apr. 2001, lot 111).

29. According to Philippe de Chennevières, *Souvenirs d'un directeur des Beaux-Arts* (Paris: Aux bureaux de l'Artiste, 1883–89), 2:56.

30. With Jean-François Heim Gallery, Paris, 2003.

31. He also published under the pseudonym Frédéric de La Faloise.

32. See Delacroix's letter to de Mercey dated 19 May 1838, in *Correspondance générale d'Eugène Delacroix,* ed. André Joubin, 5 vols. (Paris: Plon, 1936–38), 2:11–12.

33. Vincent Pomarède, "Eugène Delacroix: The State, Collectors, and Dealers," in *Delacroix: The Late Work,* exh. cat. (Philadelphia: Philadelphia Museum of Art, 1998), 54–55.

34. *Journal de Eugène Delacroix,* ed. André Joubin (Paris: Plon, 1932) 1:277–78, entry dated 21 March 1849.

35. For Ingres's correspondence see Patricia Mainardi, *Art and Politics of the Second Empire: The Universal Expositions of 1855 and 1867* (New Haven: Yale University Press, 1987), 51; for Delacroix, see Joubin, *Correspondance générale d'Eugène Delacroix,* 3:250–52.

36. Chennevières, *Souvenirs,* 2:56–57.

37. The records of the Ministry of the Interior contain numerous requests submitted by Frédéric de Mercey for leaves of absence, beginning in 1845; Dossiers individals des fonctionnaires de l'administration centrale du ministère de l'intérieur, F 1bI 273/3; Dossier de fonctionnaire de Frédéric Bourgeois de Mercey, F70 357, Archives Nationales de France, Paris.

38. Chennevières, *Souvenirs,* 2:57.

39. Anne de Mondenard, *La Mission héliographique: cinq photographes parcourent la France en 1851* (Paris: Centre des monuments nationaux: Monum, Éditions du patrimoine, 2002), 34.

40. The daguerreotype is reproduced in Bernard Marbot and Weston J. Naef, *After Daguerre: Masterworks of French Photography (1848–1900) from the Bibliothèque Nationale,* exh. cat. (New York: Metropolitan Museum of Art, 1981), 166, no. 164. Sylvie Aubenas has identified the setting with Baron Gros (compare the props with those shown in Gros's daguerreotype *The Salon of the Photographer with an Exhibition of Daguerreotypes,* illustrated in André Jammes and Eugenia Parry Janis, *The Art of French Calotype, with a Critical Dictionary of Photographers, 1845–1870* [Princeton, N.J.: Princeton University Press, 1983], 8), and has discovered the words "cher Frédéric" scratched into the metal plate in the area of the letter; written communication to author, 6 Jan. 2003. The man bears a strong resemblance to Frédéric de Mercey.

41. "C'est ainsi que MM. Bayard et Cousin ont présenté à la société héliographique des ciels qui faisaient l'éton nement des artistes, au nombre desquels M. de Mercey, l'illustre paysagiste, se faisant remarquer par son admiration et les éloges dont il a honoré ces messieurs. Tels sont ces procédés qui relient intimement l'héliographie aux beaux arts." "Communication Intéressante," *La Lumière,* 23 Feb. 1851, 10–11.

42. "Revue Photographique: M. Baldus," *La Lumière,* 1 July 1854, 103.

43. *Explication des ouvrages de peinture, sculpture, gravure, lithographie et architecture des artistes vivants étrangers et français . . .* (Paris: Museés Imperiaux, 1855), xviii–xx.

44. The painting *Joueur d'orgue* (no. 3730) had been exhibited previously in the Salon of 1853. Lacan described the photograph in *Esquisses photographiques* (1856; repr., New York: Arno Press, 1979), 150–51.

45. The announcement of Baldus's membership in the Société française de photographie was made in "Assemblée Générale de la Société: Procès-verbal de la séance du 16 janvier 1857," *Bulletin de la Société française de photographie* 3 (Feb. 1857): 29.

46. "Assemblée Générale de la Société: Procès-verbal de la séance du 18 avril 1856," *Bulletin de la Société française de photographie* 2 (May 1856): 137–38.

47. "Exposition annuelle de la Société," *Bulletin de la Société française de photographie* 2 (Nov. 1856): 324.

48. Société française de photographie, *Catalogue de la deuxième exposition annuelle des œuvres des artistes et amateurs français et étrangers . . .* (Paris, n.d.), 3–4.

49. Daniel, *Photographs of Édouard Baldus,* 266, n. 166.

50. *Catalogue de la deuxième exposition annuelle des œuvres des artistes et amateurs français et étrangers* (Paris: Mallet-Bachelier, 1857), 4–5. In *The Invention of Photography* (New York: Harry N. Abrams, 2002), 49, Quentin Bajac states that Baldus employed a waxed paper negative in fig. 1.

51. See Daniel, *Photographs of Édouard Baldus,* appendix I, "Signatures and Stamps," 229.

52. As in the exhibition that generated this publication, *Édouard Baldus: Landscape and Leisure in Early French Photography,* Sterling and Francine Clark Art Institute, Williamstown, Mass., 4 Oct. 28 Dec. 2003.

53. See Eugène Durieu, "Sur la retouche des Épreuves photographiques," *Bulletin de la Société française de photographie* 1 (Oct. 1855): 297–304.

54. "Seront également exclues de l'Exposition toutes épreuves coloriées, et toutes celles qui présenteraient des retouches essentielles, de nature à modifier le travail photographique proprement dit, en y substituant un travail manuel." "Exposition annuelle de la Société française de photographie," *Bulletin de la Société française de photographie* 2 (Oct. 1856): 295.

55. See the review of Aguado's photographs in the Exposition Universelle, "Documents officiels pour servir à l'histoire de la photographie: extrait des rapports du jury mixte international de l'Exposition universelle," *La Lumière,* 2 May 1857, 71; and Philippe Burty's review of the third exhibition of the Société française de photographie, in the *Gazette des Beaux-Arts* 1 (15 May 1859): 217.

56. Malcolm Daniel, "The Photographic Railway Albums of Edouard-Denis Baldus," (Ph.D. diss., Princeton University, 1991), 481–82.

57. Elizabeth Anne McCauley, *A. A. E. Disdéri and the Carte de Visite Portrait Photograph* (New Haven: Yale University Press, 1985), 142–44.

58. Deterioration of this type has been studied by Mark H. McCormick-Goodhart and presented by him in a paper, "Glass Corrosion and Its Relation to Image Deterioration in Collodion Wet-Plate Negatives," delivered at the conference "The Imperfect Image: Photographs their Past, Present and Future," hosted by the Centre for Photographic Conservation at Windermere on 6–10 April 1992. The paper was included in the published conference proceedings, *The Imperfect Image: Photographs their Past, Present, and Future* (London: Centre for Photographic Conservation, 1992), 256–65.

59. See Anne Cartier-Bresson, "The Negatives of Gustave Le Gray in the Bibliothèque Historique de la Ville de Paris," in Sylvie Aubenas et al., *Gustave Le Gray, 1820–1884,* ed. Gordon Baldwin, exh. cat. (Los Angeles: The J. Paul Getty Museum, 2002), 286–95.

60. A. A. E. Disdéri, *L'art de la photographie* (Paris: Disdéri, 1862), 277.

61. Iveagh Bequest, Kenwood (London, England), *The Conversation Piece in Georgian England,* exh. cat. (London: Greater London Council, 1965), quoted in Ronald Paulson, *Emblem and Expression: Meaning in English Art of the Eighteenth Century* (London: Thames and Hudson, 1975), 121.

62. Ibid., 123.

63. See, for instance, Balthasar Nebot's eight views of Hartwell House, painted in 1738 (Buckinghamshire County Museum, Aylesbury), reproduced in John Harris, *The Artist and the Country House: A History of Country House and Garden View Painting in Britain, 1540–1870,* rev. ed. (New York: Sotheby's, 1985), 188–89.

64. Sara Stevenson, *David Octavius Hill and Robert Adamson: Catalogue of Their Calotypes Taken Between 1843 and 1847 in the Collection of the Scottish National Portrait Gallery* (Edinburgh: National Gallery of Scotland, 1981), 160–61, Groups 71–75; 210, Landscapes 1–4.

65. "Henry Fox Talbot: Conversation Pieces," in *British Photography in the Nineteenth Century: The Fine Art Tradition,* ed. Mike Weaver (Cambridge: Cambridge University Press, 1989), 11–23.

66. See Geneviève Bresc-Bautier and Françoise Heilbrun, *Le photographe et l'architecte: Édouard Baldus, Hector-Martin Lefuel et le chantier du Nouveau Louvre de Napoléon III,* exh. cat., Les dossiers du musée du Louvre 47 (Paris: Réunion des Musées Nationaux, 1995).

67. Geneviève Bresc-Bautier and Anne Pingeot, *Sculptures des jardins du Louvre, du Carrousel et des Tuileries,* 2 vols. (Paris: Editions de la Reunion des Musées Nationaux, 1986), 1:100–13. A group of Baldus's photographs taken in the Tuileries appeared at Drouot Richelieu, Paris, on 24 Jan. 2003 in the sale *Photographies anciennes et modernes,* Marc Pagneux, expert, 13–14, lots 5–11. The prints may be traced to Hector Lefuel via his successor E. Janty.

68. Bresc-Bautier and Pingeoit, *Sculptures des jardins,* 2:457–58. A number of marble benches were transferred from Marly to the Tuileries Garden during the late eighteenth century. One of the benches illustrated by Bresc-Bautier and Pingeoit corresponds precisely with the one shown in fig. 35.

69. This photograph was first published as a self-portrait of Baldus in Erika Billeter, ed., *Das Sebstportrait im Zeitalter der Photographie: Maler und Photographen im Dialog mit sich selbst,* exh. cat. (Stuttgart: Württembergischer Kunstverein, 1985), no. 118, 152, 482. The print illustrated belonged to the Texbraun Collection, Paris. While there is no documentary evidence that this photograph is, in fact, a self-portrait of Baldus, the figure closely resembles the presumed half-length self-portrait of Baldus in the collection of the Bibliothèque nationale de France (fig. 12).

70. Quoted in *A Day in the Country,* 214.

71. Dianne W. Pitman, *Bazille: Purity, Pose and Painting in the 1860s* (University Park, Pa.: Pennsylvania State University, 1998), 87.

72. Quoted in ibid.

73. See Jammes and Janis, *Art of French Calotype,* 96–101, for an excellent discussion of this issue.

74. "Théorie du portrait-I," *La Lumière,* 27 April 1851, 46–47; "Théorie du portrait-II," *La Lumière,* 4 May 1851, 50–51.

75. See his essay "Gustave Le Gray, Heliographer-Artist," in Sylvie Aubenas et al., *Gustave Le Gray, 1820–1884,* ed. Gordon Baldwin, exh. cat. (Los Angeles: J. Paul Getty Museum, 2002), 228–31.

76. *Études sur les beaux-arts depuis leur origine jusqu'à nos jours* (Paris: A. Bertrand, 1855–57), 1:25–26. Although the term "daguerreotype" was frequently used to indicate "photography" in general during this period, de Mercey's meaning is unclear.

77. See Disdéri, *L'art de la photographie,* 272–73.

78. Quoted (and translated) in Daniel, *The Photographs of Édouard Baldus,* 63.

79. Published in *Le spleen de Paris: petites poèmes en prose* (1868); see *The Parisian Prowler: Le spleen de Paris: petits poèmes en prose,* 2nd ed., Edward K. Kaplan, trans. and ed. (Athens, Ga.: The University of Georgia Press , 1997), 93.

80. "Exposition photographique," *L'Artiste* 3 (8 Mar. 1857): 193–95.

81. For instance, no print is known of Baldus's panoramic landscape photograph of Mont-Dore, praised by Ernest Lacan as the masterpiece of landscape photography in the Exposition Universelle. See Lacan, *Esquisses photographiques,* 80–81.

82. D. F. Millet, a daguerreotypist active in Paris during the 1850s; see Bernard Marbot et al., *After Daguerre: Masterworks of French Photography (1848–1900) from the Bibliothèque Nationale,* exh. cat. (New York: Metropolitan Museum of Art, 1980), 103. He exhibited five portraits in the second exhibition of the Société française de photographie, 1857 (see p. 15, no. 68).

83. Claude-Marie Ferrier (1811–1889) exhibited a group of stereoscopes in the second exhibition of the Société française de photographie, 1857. See ibid., 10, no. 38.

84. J. M. Taupenot (1824–1856). See B. M., "Nouveau procédé photographique de M. Taupenot, Docteur [d]es Sciences, professeur de Chimie au Prytanée imperial militaire," *Bulletin de la Société française de photographie* 1 (Sept. 1855): 233–53.

List of Photographs of the Château de La Faloise

Édouard Baldus made nine known photographs of the Château de La Faloise in 1856, some of which have several prints. Details for each print are given below. Recent exhibitions that included these works are referenced as follows:

Malibu 1992 *Camille Silvy: River Scene, France,* J. Paul Getty Museum, 1992 (15 December 1992–28 February 1993)

New York 1993 *The Waking Dream: Photography's First Century,* Metropolitan Museum of Art, New York (25 March–4 July 1993)

New York-Montreal-Paris 1994 *The Photographs of Édouard Baldus,* Metropolitan Museum of Art, New York (3 October–31 December 1994; traveled to Canadian Centre for Architecture, Montreal [24 January–23 April 1995] and to Musée National des Monuments Français, Paris [13 May–11 August 1995])

Philadelphia-Detroit-Paris 1978 *The Second Empire, 1852–1870: Art in France under Napoleon III,* Philadelphia Museum of Art (1 October–26 November 1978; traveled to the Detroit Institute of Arts [15 January–18 March 1979] and Grand Palais, Paris [24 April–2 July 1979])

Washington-Worcester-Chapel Hill 1982 *Visions of City & Country: Prints and Photographs of Nineteenth-Century France,* Worcester Art Museum, Worcester, Massachusetts (7 January–3 March 1983; opened at National Gallery of Art, Washington, D.C. [3 October–28 November 1982] and traveled to Ackland Art Museum, University of North Carolina at Chapel Hill [6 March–10 April 1983])

Williamstown 1999 *Early Photography / Eight Months Out: Recent Acquisitions by the Clark Art Institute,* Sterling and Francine Clark Art Institute, Williamstown, Massachusetts (5 March–18 June 1999)

Williamstown 2003 *Édouard Baldus: Landscape and Leisure in Early French Photography,* Sterling and Francine Clark Art Institute, Williamstown, Massachusetts (4 October–28 December 2003)

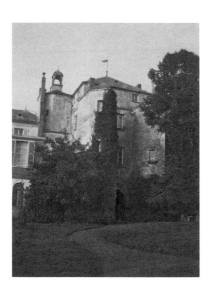

1. Tower of the Château de La Faloise

Salted paper print from wet-collodion-on-glass negative, with hand-coloring in black ink
Image: 13 ⅛ x 10 ⅝ in. (33.3 x 27 cm)
Mount: 25 x 18 ¾ in. (63.4 x 47.6 cm)
Sterling and Francine Clark Art Institute, Williamstown, Massachusetts (2002.2)

Provenance: Georges Sirot; Gérard Lévy; purchased by the Sterling and Francine Clark Art Institute, 2002
Exhibition: Williamstown 2003
Fig. 18

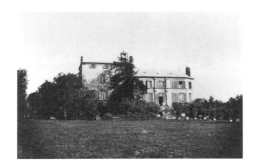

2. Garden Façade of the Château de La Faloise
Two prints are known from this negative

a) Salted paper print from wet-collodion-on-glass negative
Image: 10⅞ x 16⅛ in. (27.7 x 41 cm)
Mount: 18¾ x 24⅝ in. (47.5 x 62.7 cm)
Bibliothèque nationale de France, Paris (Eo 8 A grand folio)

Provenance: Georges Sirot; Galerie Texbraun, Paris; Galerie Baudoin-Lebon, Paris; purchased by the Bibliothèque nationale, 1999
Fig. 20

b) Salted paper print from wet-collodion-on-glass negative, albumenized, with retouching along lower edge
Image: 11 x 15¾ in. (27.9 x 40 cm)
Mount: 19⅛ x 25 in. (48.5 x 63.5 cm)
Mount inscribed in blue ink, verso: La photographie ci-contre dont je possède le même exemplaire / porte en bas et à droite la griffe de Baldus. / Georges Sirot [signature]
Sterling and Francine Clark Art Institute, Williamstown, Massachusetts (1999.24.1)

Provenance: Georges Sirot; Gérard Lévy; purchased by the Sterling and Francine Clark Art Institute, 1999
Exhibitions: Williamstown 1999, Williamstown 2003

3. Château de La Faloise, Late Morning
Salted paper print from wet-collodion-on-glass negative, with retouching in pencil
Image: 12⅛ x 15¾ in. (30.7 x 40 cm)
Mount: 18¾ x 24⅞ in. (47.6 x 63.2 cm)
Mount inscribed in pencil, verso: Photographie de E. Baldus / Georges Sirot [signature]
Sterling and Francine Clark Art Institute, Williamstown, Massachusetts (1998.44)

Provenance: Georges Sirot; Gérard Lévy; purchased by the Sterling and Francine Clark Art Institute, 1998
Exhibitions: Washington-Worcester-Chapel Hill 1982, Williamstown 1999, Williamstown 2003
Fig. 21

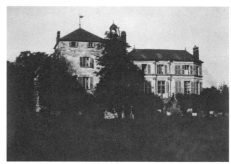

4. Château de La Faloise, Late Afternoon

Salted paper print from wet-collodion-on-glass negative
Image: 11 ⅝ x 16 ½ in. (29.5 x 42 cm)
Mount: 19 ¼ x 25 in. (48.8 x 63.5 cm)
Mount inscribed in pencil, along lower right edge, recto: Baldus.
Château de La Faloise—Expo SFP. 1857
Private collection, New York

Provenance: Georges Sirot; Gérard Lévy; Private collection, France;
Gérard Lévy; to private collection, New York, 2000
Exhibition: Williamstown 2003
Fig. 22

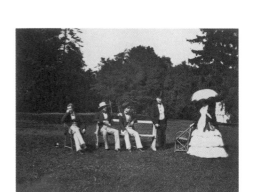

5. Group Portrait at the Château de La Faloise

Two prints are known from this negative

a) Salted paper print from wet-collodion-on-glass negative
Image: 10 ¹⁵⁄₁₆ x 15 ¹⁄₁₆ in. (27.8 x 38.2 cm)
Mount: 16 ⅜ x 21 ¾ in. (41.5 x 55.4 cm)
The Metropolitan Museum of Art, New York. Gilman Collection,
Purchase, The Horace W. Goldsmith Foundation Gift through
Joyce and Robert Menschel, 2005 (2005.100.50)

Provenance: Georges Sirot; Galerie Texbraun; purchased by the Gilman
Paper Company, 1978; acquired by the Metropolitan Museum of Art,
New York, 2005
Exhibitions: New York 1993, New York-Montreal-Paris 1994,
Williamstown 2003
Fig. 23

b) Salted paper print from wet-collodion-on-glass negative
Image: 11 ⅝ x 15 ¾ in. (29.4 x 40 cm)
Mount: 19 ¼ x 25 ⅛ in. (48.9 x 63.8 cm)
Mount inscribed in blue ink, verso: La photographie ci-contre dont je
possède un semblable exemplaire / porte en bas et à droite la griffe
de Baldus / Georges Sirot [signature]
Mount stamped in blue ink, verso, lower right: Gérard Lévy / 17, rue
de Beaune / Paris-7e,
Private collection, on loan to the Museum of Fine Arts, Boston

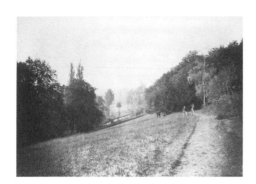

Provenance: Georges Sirot; Gérard Lévy; to private collection, early 1970s

Exhibition: Washington-Worcester-Chapel Hill 1982

Fig. 2

6. View from the Château de La Faloise

Salted paper print from wet-collodion-on-glass negative

Image: 12 ⅜ x 16 ⅞ in. (31.4 x 43 cm)

Mount: 19 ⅛ x 25 in. (48.5 x 63.5 cm)

Mount inscribed in black ink, verso: La photographie ci-contre dont
Je possède le Même exemplaire / porte en bas et à droite, la griffe de
Baldus. / G. Sirot [signature]; in pencil: chateau de 'Le Flessiere' / 1857
(3 eme anniversaire)

Mount stamped in blue ink, verso: Gérard Lévy / 17, rue de Beaune /
Paris-7e

Canadian Centre for Architecture, Montreal (PH1986:0346)

Provenance: Georges Sirot; Gérard Lévy; Harry Lunn; purchased
by the Canadian Centre for Architecture, early 1970s

Exhibitions: Williamstown 2003

Fig. 24

7. Footbridge at La Faloise I

Three prints are known from this negative

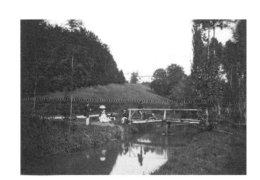

a) Salted paper print from wet-collodion-on-glass negative

Image: 11 ⅜ x 16 in. (29 x 40.8 cm)

Mount: 18 ⅛ x 23 ⅝ in. (46 x 60 cm)

Mount inscribed in dark blue ink, verso: La photographie ci-contre
dont je possède le même exemplaire, porte en bas à droite la griffe
de Baldus / Georges Sirot [signature]

Stamped in blue ink, verso: Gérard Lévy / 17, rue de Beune / Paris-7e

Musée d'Orsay, Paris. Gift of the Kodak-Pathé Foundation
(Pho 1983-165-2)

Provenance: Georges Sirot; Gérard Lévy; purchased by Musée Kodak-
Pathé, Vincennes, c. 1967 (inv. no. 2362); transferred to the Musée
d'Orsay, Paris, 1983

Exhibitions: Philadelphia-Detroit-Paris 1978, New York-Montreal-Paris
1994, Williamstown 2003

Fig. 1

b) Salted paper print from wet-collodion-on-glass negative, lightly albumenized

Image: 11 ¼ x 16 ⅝ in. (28.7 x 42.3 cm)

Mount: 14 x 18 ½ in. (35.7 x 47.1 cm)

Mount stamped in blue ink at lower right, recto: E. Baldus

[see Malcom Daniel, *The Photographs of Édouard Baldus* (New York: Metropolitan Museum of Art, 1994), appendix 1, no. 5]

Musée d'Art Moderne et Contemporain, Strasbourg (77-981-0-52)

Provenance: Georges Sirot? (The museum has no record of the previous owner; the work has been in the museum's collection since at least 1981)

Fig. 26

c) Albumen print from wet-collodion-on-glass negative

Image: 11 ¼ x 16 ¾ in. (28.7 x 42.6 cm)

Mount: 14 ¾ x 19 ½ in. (37.5 x 49.5 cm)

Mount stamped in purple ink, verso: G. SIROT / 35, rue Jacob, 35 / PARIS-VIe

Collection of JGS, Inc., New York

Provenance: Georges Sirot; André Jammes(?); Van Deren Coke; Hans Kraus, Jr., New York; Lee Marks Fine Art, Indiana; acquired by JGS Inc., 1992

Exhibition: Malibu 1992

8. Footbridge at La Faloise II

Salted paper print from wet-collodion-on-glass negative

Image: 11¼ x 16 ¼ in. (28.6 x 41.4 cm)

Mount: 19 ⅛ x 25 ⅛ in. (48.6 x 63.7 cm)

Mount stamped in blue ink at lower right, recto: E. Baldus [see Daniel, *The Photographs of Édouard Baldus,* appendix 1, no. 5]

Mount stamped in blue ink above center, verso: G. SIROT / 35, rue Jacob, 35 / PARIS-VIe

Philadelphia Museum of Art. Purchased with funds contributed by the American Museum of Photography (1970-243-3)

Provenance: Georges Sirot; Gérard Lévy; purchased by the Philadelphia Museum of Art, 1970

Exhibition: Williamstown 2003

Fig. 27

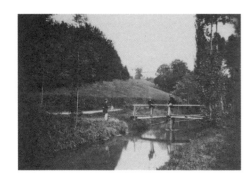

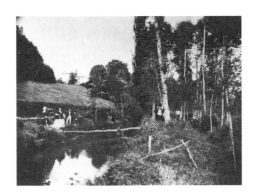

9. Group on the Riverbank

Salted paper print from wet-collodion-on-glass negative

Image: 11 ¾ x 15 ⅜ in. (29.7 x 39.2 cm)

Mount: 19 ¼ x 24 ⅞ in. (48.9 x 63.2 cm)

Bibliothèque nationale de France, Paris (BL 10667, Eo 8 A grand folio)

Provenance: Georges Sirot; Galerie Texbraun, Paris; Galerie Baudoin-Lebon, Paris; purchased by the Bibliothèque nationale, 1999

Exhibition: Williamstown 2003

Fig. 29

Photographs of the Château de La Faloise in 2001

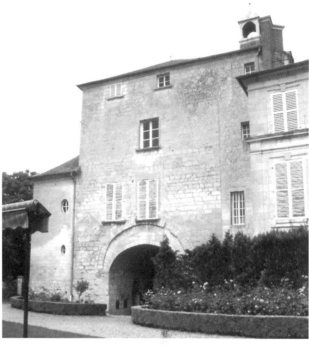

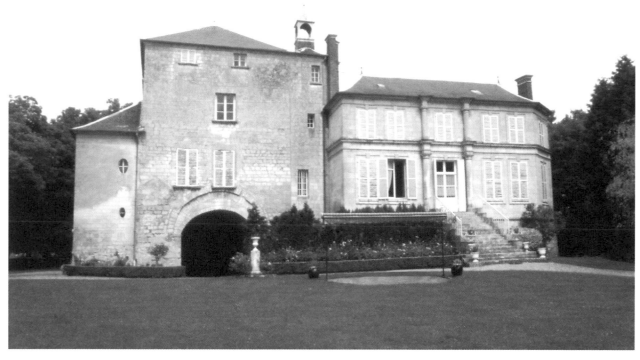

"Assemblée Générale de la Société: Procès-verbal de la séance du 18 avril 1856." *Bulletin de la Société française de photographie* 2 (May 1856): 129–38.

"Assemblée Générale de la Société: Procès-verbal de la séance du 16 janvier 1857." *Bulletin de la Société française de photographie* 3 (Feb. 1857): 29–42.

Aubenas, Sylvie, et al. *Gustave Le Gray, 1820–1884.* Edited by Gordon Baldwin. Exh. cat. Los Angeles: J. Paul Getty Museum, 2002.

Bajac, Quentin. *The Invention of Photography.* New York: Harry N. Abrams, 2002.

Barthes, Roland. *Camera Lucida: Reflections on Photography.* Translated by Richard Howard. New York: Hill and Wang, 1981.

Bation-Cabaud, Eliette. "Georges Sirot, 1898–1977, une collection de photographies anciennes." *Photogénies,* no. 3 (Oct. 1983): unpaginated.

Beauvillé, Victor de. *Recueil de documents inédits concernant la Picardie.* 5 vols. Paris: Impériale, 1860–82.

Billeter, Erika, ed. *Das Selbstportrait im Zeitalter der Photographie: Maler und Photographen im Dialog mit sich selbst.* Exh. cat. Stuttgart: Württembergischer Kunstverein, 1985.

Blanc, Charles. "M. Frédéric de Mercey." *Gazette des Beaux-Arts* 7 (15 Sept. 1860): 374–76.

Boisdenier, B. de. "M. F. de Mercey." *Le Siècle,* 8 Jan. 1861.

Bresc-Bautier, Geneviève, and Françoise Heilbrun. *Le photographe et l'architecte: Édouard Baldus, Hector-Martin Lefuel et le chantier du Nouveau Louvre de Napoléon III.* Exh. cat. Les dossiers du musée du Louvre 47. Paris: Réunion des musées nationaux, 1995.

Burty, Philippe. "Exposition de la Société française de photographie." *Gazette des Beaux-Arts* 1 (15 May 1859): 209–21.

Chennevières, Philippe de. *Souvenirs d'un directeur des Beaux-Arts.* 5 vols. Paris: Aux bureaux de l'Artiste, 1883–89.

Christ, Yvan. *Dictionnaire des châteaux de France.* Paris: Berger-Levrault, 1978.

Daguerre, Louis Jacques. "Daguerreotype." Paris: Pollet, Soupe et Gillois, 1838–39. Reprinted in *Le daguerréotype français:*

Un objet photographique by Quentin Bajac and Dominique Planchon-de Font-Reaulx. Exh. cat. Paris: Réunion des musées nationaux; Musée d'Orsay, 2003.

Daniel, Malcolm. "The Photographic Railway Albums of Edouard-Denis Baldus." Ph.D. diss., Princeton University, 1991.

———. *The Photographs of Édouard Baldus.* Exh. cat. New York: Metropolitan Museum of Art, 1994.

Delacroix, Eugène. *Correspondance générale d'Eugène Delacroix.* Edited by André Joubin. 5 vols. Paris: Plon, 1936–38.

———. *Journal de Eugène Delacroix.* Edited by André Joubin. 3 vols. Paris: Plon, 1932.

Disdéri, A. A. E. *L'art de la photographie.* Paris: Disdéri, 1862.

"Documents officiels pour servir à l'histoire de la photographie: extrait des rapports du jury mixte international de l'Exposition universelle." *La Lumière,* 2 May 1857.

Dossier de fonctionnaire de Frédéric Bourgeois de Mercey. Archives Nationale de France, Paris.

Dossiers individuals des fonctionnaires de l'administration centrale du ministère d l'intérieur. Archives Nationales de France, Paris.

Durieu, Eugène. "Sur la retouche des Épreuves photographiques." *Bulletin de la Société française de photographie* 1 (Oct. 1855): 297–304.

Explication des ouvrages de peinture, sculpture, gravure, lithographie et architecture des artistes vivants étrangers et français Paris: Musées Imperiaux, 1855.

"Exposition annuelle de la Société." *Bulletin de la Société française de photographie* 2 (Nov. 1856): 324.

"Exposition annuelle de la Société française de photographie." *Bulletin de la Société française de photographie* 2 (Oct. 1856): 295–96.

"Frédéric de Mercey." *L'Artiste* 10 (15 Sept. 1860): 141–42.

Ganz, James A. *Édouard Baldus: Landscape and Leisure in Early French Photography.* Exhibition website, 4 Oct.–28 Dec 2003, *http://www.clarkart.edu/exhibitions/baldus/.*

Gautier, Théophile. "Exposition photographique." *L'Artiste* 3 (8 Mar. 1857): 193–95.

Grad, Bonnie Lee, and Timothy A. Riggs. *Visions of City and Country: Prints and Photographs of Nineteenth-Century France*. Exh. cat. Worcester, Mass.: Worcester Museum of Art, 1982.

Hambourg, Maria Morris. *The Waking Dream: Photography's First Century*. Exh. cat. New York: Metropolitan Museum of Art, 1993.

Heilbrun, Françoise. *Les paysages des impressionnistes*. Paris: Éditions Hazan, Éditions de la Réunion des musées nationaux, 1986.

Hoefer, M. *Nouvelle biographie générale depuis les temps les plus reculés jusqu'à 1850–60*. 46 vols. 1852–66. Reprint, Copenhagen: Rosenkilde et Bagger, 1968.

Invéntaire après décès de Frédéric Bourgeois de Mercey. Archives Nationales de France, Paris.

Jammes, André, and Eugenia Parry Janis. *The Art of French Calotype, with a Critical Dictionary of Photographers, 1845–1870*. Princeton, N.J.: Princeton University Press, 1983.

Lacan, Ernest. *Esquisses photographiques*. 1856. Reprint, New York: Arno Press, 1979.

————. "La photographie à la campagne." *La Lumière*, 18 July 1857.

————. "Revue Photographique: M. Baldus." *La Lumière*, 1 July 1854.

Los Angeles County Museum of Art. *A Day in the Country: Impressionism and the French Landscape*. Exh. cat. Los Angeles: Los Angeles County Museum of Art, 1984.

Mainardi, Patricia. *Art and Politics of the Second Empire: The Universal Expositions of 1855 and 1867*. New Haven: Yale University Press, 1987.

Marbot, Bernard, and Weston J. Naef. *After Daguerre: Masterworks of French Photography (1848–1900) from the Bibliothèque Nationale*. Exh. cat. New York: Metropolitan Museum of Art, 1981.

McCauley, Elizabeth Anne. *A. A. E. Disdéri and the Carte de Visite Portrait Photograph*. New Haven: Yale University Press, 1985.

McCormick-Goodhart, Mark H. "Glass Corrosion and Its Relation to Image Deterioration in Collodion Wet-Plate Negatives." In *The Imperfect Image: Photographs their Past, Present, and Future*. London: Centre for Photographic Conservation, 1992.

Mercey, Frédéric Bourgeois de. *Études sur les beaux-arts depuis leur origine jusqu'à nos jours*. 3 vols. Paris: A. Bertrand, 1855–57.

Mollet, Jules. *Montdidier: Géographie historique et statistique de l'arrondissement*. Monographies des villes et villages de France, no. 4. 1889. Reprint, Paris: Res Universis, 1992.

Mondenard, Anne de. *La Mission héliographique: cinq photographes parcourent la France en 1851*. Paris: Centre des monuments nationaux: Monum, Éditions du patrimoine, 2002.

————. "La ronde des collectionneurs." In Roger Thérond, *Une passion française, photographies de la collection de Roger Thérond*. Exh. cat. Paris: Filipacchi: Maison européenne de la photographie, 1999.

Montfort, Benito de. "Communication Intéressante." *La Lumière*, 23 Feb. 1851.

Musée Kodak-Pathé. *Présence de la photographie*. Paris: Musée Kodak-Pathé, 1969.

Newhall, Beaumont. *The History of Photography: From 1839 to the Present*. Rev. ed. New York: Museum of Modern Art, 1982.

Philadelphia Museum of Art. *The Second Empire, 1852–1870: Art in France under Napoleon III*. Exh. cat. Philadelphia: Philadelphia Museum of Art, 1978.

Pitman, Dianne W. *Bazille: Purity, Pose, and Painting in the 1860s*. University Park, Pa.: Pennsylvania State University, 1998.

Seydoux, Philippe. *Gentilhommières en Picardie, Amiénois et Santerre*. Paris: La Morande, 2002.

Société des antiquaires de Picardie. Fondation Edmond Soyez. *La Picardie historique et monumentale: tome 2, arrondissement de Montdidier*. Amiens: Imprimerie Yvert et Tellier; Paris: Libraire A. Picard, 1901–2.

Société française de photographie. *Catalogue de la deuxième exposition annuelle des œuvres des artistes et amateurs français et étrangers* Paris: Mallet-Bachelier, 1857.

Stevenson, Sara. *David Octavius Hill and Robert Adamson: Catalogue of Their Calotypes Taken Between 1843 and 1847 in the Collection of the Scottish National Portrait Gallery*. Edinburgh: National Gallery of Scotland, 1981.

Talbot, William Henry Fox. *The Pencil of Nature*. London: Longman, Brown, Green, and Longmans, 1844.

Weaver, Mike, ed. *British Photography in the Nineteenth Century: The Fine Art Tradition*. Cambridge: Cambridge University Press, 1989.

Wey, Francis. "Théorie du portrait-I." *La Lumière*, 27 April 1851.

————. "Théorie du portrait-II." *La Lumière*, 4 May 1851.

DATE DUE

DEMCO, INC. 38-2931